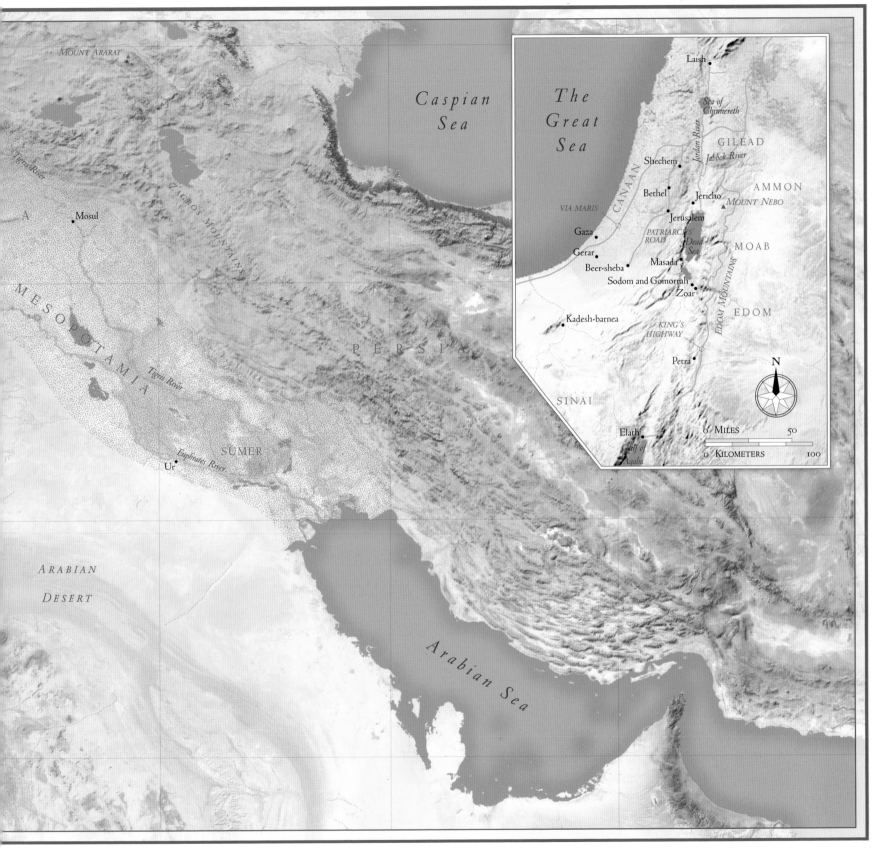

Caspian
Sea

The
Great
Sea

Laish

Sea of
Chinnereth

GILEAD

Shechem

Jordan River

Jabbok River

Bethel

AMMON

Jericho

MOUNT NEBO

VIA MARIS

CANAAN

Jerusalem

Gaza

PATRIARCHS'
ROAD

Dead
Sea

Gerar

MOAB

Beer-sheba

Masada

Sodom and Gomorrah

Zoar

Kadesh-barnea

EDOM

KING'S
HIGHWAY

EDOM MOUNTAINS

MOUNT ARARAT

Petra

N

Tigris River

Mosul

ZAGROS MOUNTAINS

SINAI

MESOPOTAMIA

Elath

0 MILES 50

PERSIA

Gulf of
Aqaba

0 KILOMETERS 100

Tigris River

Euphrates River

SUMER

A

Ur

ARABIAN

DESERT

Arabian Sea

WALKING THE BIBLE

A Photographic Journey

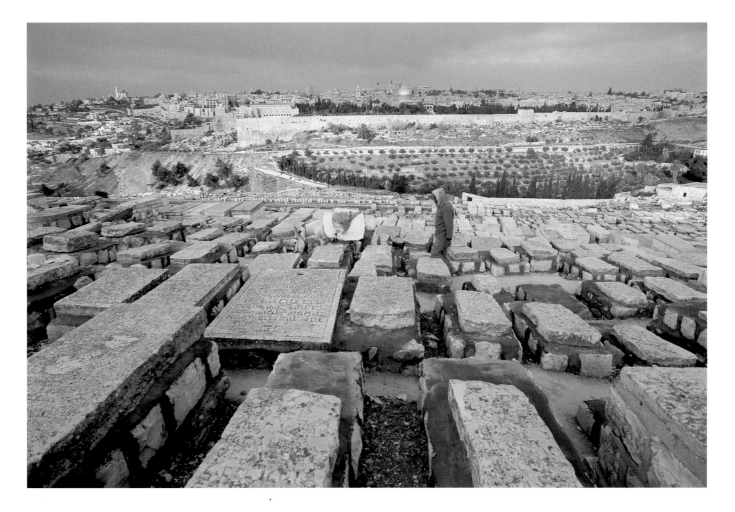

ALSO BY BRUCE FEILER

Where God Was Born
A Journey by Land to the Roots of Religion

Abraham
A Journey to the Heart of the Three Faiths

Walking the Bible
A Journey by Land Through the Five Books of Moses

Dreaming Out Loud
Garth Brooks, Wynonna Judd, Wade Hayes, and the Changing Face of Nashville

Under the Big Top
A Season with the Circus

Looking for Class
Days and Nights at Oxford and Cambridge

Learning to Bow
Inside the Heart of Japan

Walking the Bible
An Illustrated Journey for Kids Through the Greatest Stories Ever Told

WALKING

BRUCE FEILER

THE BIBLE

A Photographic Journey

WM

WILLIAM MORROW
An Imprint of HarperCollinsPublishers

All the photographs in this book were taken by the author, except those noted here. Thanks to Andrew Feiler for the use of his photographs on pages 79, 80–81, 136–137, and 145, right; to David Wallace for the photograph on page 91, top; and to Avner Goren for those on pages 29, right, and 149. Additional acknowledgment is made to the following for permission to use their copyrighted images: Page 1: Masterfile (Royalty-Free Div.); 4–5: Jean-Luc Manaud/RAPHO; 11: QT Luong/terragalleria.com; 12: Dennis Cox/WorldViews; 22–23: Nik Wheeler; 33, right center: Tijen Burultay/Coral Plane; 33, right top: Roxane Photo; 34, left: Izzet Keribar/IML; 36–37: Sebnem Eras/ATLAS; 40–41: Annie Griffiths Belt/National Geographic Image Collection; 42–43: QT Luong/terragalleria.com; 44–45: Denis Waugh/Stone/Getty Images; 48: Sarkis Images/Alamy; 49: QT Luong/terragalleria.com; 52, top: Shai Ginott; 52, bottom: Georg Gerster/RAPHO; 53: Jad Al-Younis; 54: Freeman Patterson/Masterfile; 55: Freeman Patterson/Masterfile; 56–57: Freeman Patterson/Masterfile; 63: Richard Nowitz/Ponkawonka.com; 64 left: Sherwood Burton/Ponkawonka.com; 68: Frans Lemmens/Iconica; 82: Robert Caputo/Aurora/IPN; 83: François Guenet/RAPHO; 84–85: Robert Caputo/Aurora/IPN; 86: Barry Iverson/Woodfin Camp/IPN; 87: Kenneth Garrett/National Geographic Image Collection; 92–93: John G. Ross/RAPHO; 93, right bottom: Photopix/Photonica; 94–95: Picture Finders/age footstock; 99, right: Eve Arnold/Magnum Photos; 106: NASA-JSC Digital Image Collection; 116, left: Annie Griffiths Belt/National Geographic Society; 126, right: Jean-Luc Manaud/RAPHO; 127: Jean-Luc Manaud/RAPHO; 130–131: Jean-Luc Manaud/RAPHO; 132–133: A. C. Waltham/Robert Harding World Imagery; 151: Royalty-Free/Corbis; 156–157: Tony Pupkewitz/RAPHO; 158: Tor Eigeland.

HarperCollins books may be purchased for educational, business, or sales promotional use. For information please write: Special Markets Department, HarperCollins Publishers, 10 East 53rd Street, New York, NY 10022.

FIRST EDITION

Designed by Laura Lindgren
Maps by Nick Springer of Springer Cartographics LLC
Endpapers maps by Nick Springer of Springer Cartographics LLC
based on maps by Jeffrey L. Ward

Printed on acid-free paper

Library of Congress Cataloging-in-Publication Data has been applied for.

ISBN-10: 0-06-079904-8
ISBN-13: 978-0-06-079904-5

05 06 07 08 09 ❖/B&T 10 9 8 7 6 5 4 3 2 1

For Avner Goren

Contents

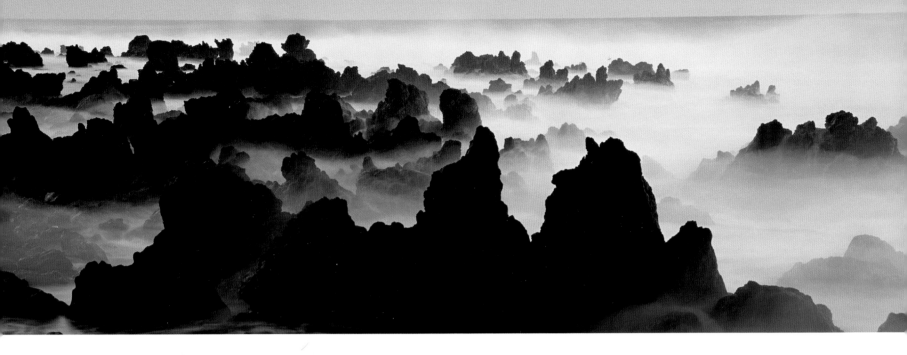

God said, "Let the water below the sky be

gathered into one area, that the dry land may appear."

And it was so. God called the dry land Earth,

and the gathering of the waters he called Seas.

And God saw that this was good.

GENESIS 1 : 9—10

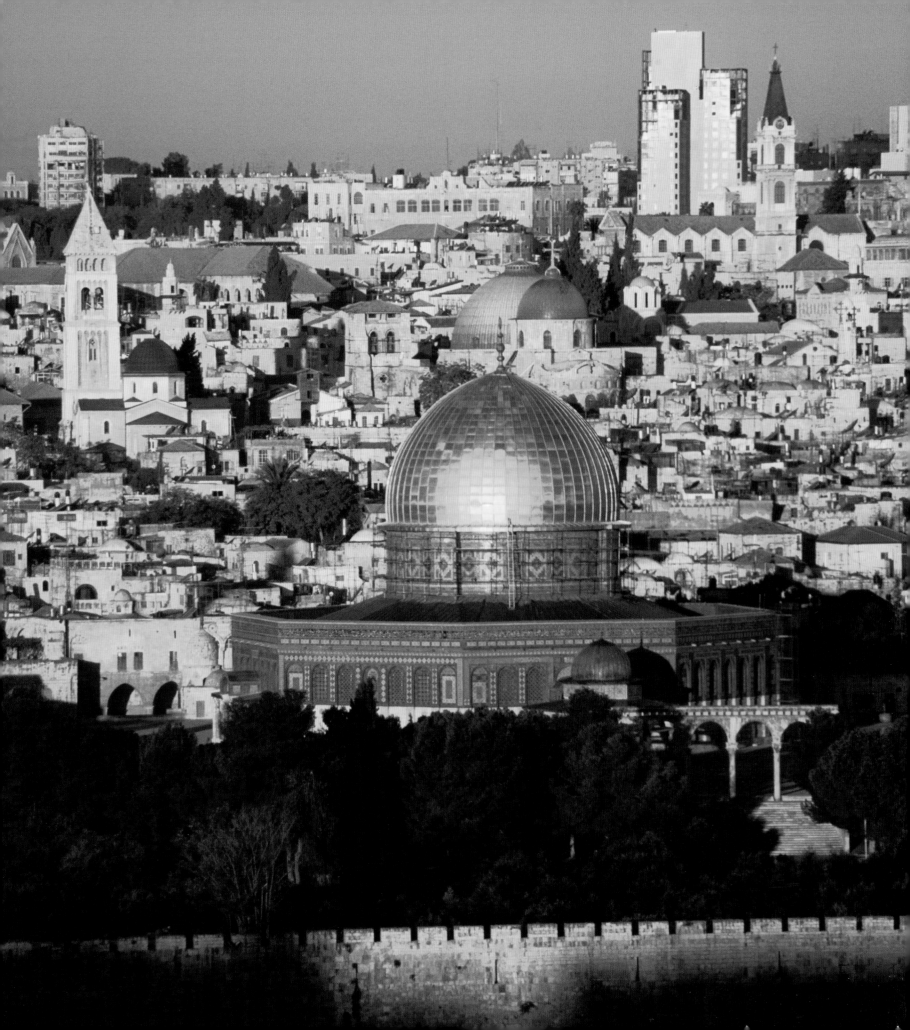

The view from the bottom of the pyramid is chilling. The stones seem to climb at an impossibly sharp angle. Each stone is about the size of a refrigerator-freezer. And the prospect of having my hand or a foot slip on the crumbling limestone, sending my body tumbling down the jagged face of this 3,600-year-old sanctum of death, is irresistible to imagine. For a second, my mind wonders how many layers a falling body would traverse. My breathing is labored. My heart is racing. It's not too late to turn back. Climbers have not been allowed here for decades; too many were dying each year.

"Are you ready?" my guide asks.

"Let's go," I say.

On a chilly, overcast winter morning, I grip the bottom layer of the second-tallest pyramid in Giza and begin the tense process of pulling, pushing, and clamoring my way to the top. I have come, with special permission in hand, to consider a question that has bedeviled lovers of the Bible for thousands of years: "Did the Israelites build the pyramids?" This question is part of a larger quest to search for the roots of the Bible in the land where it was born. Where did Noah's ark land? Is it possible to find the lost cities of Sodom and Gomorrah? Which mountain is the place where Moses received the Ten Commandments?

And above all: How can visiting the places of the Bible enhance my appreciation of the story?

The first few steps of the climb were harder than I expected. I had to search for tiny handholds in the rocks, look for corresponding footholds, then lever my

The Dome of the Rock sits on top of
the Temple Mount in the heart of Jerusalem.

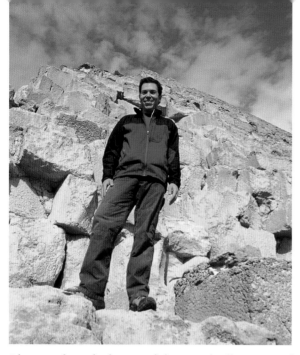

The view from the bottom of the second-tallest pyramid in Giza.

body upward as if climbing the face of a cliff. I didn't have special equipment. I was tethered to no ropes. I began to wonder if I would make it to the top. A BBC reporter had gotten halfway up the side, a friend had told me, then froze in fright. He had to be pried from his position.

A few layers up, I began to find a rhythm—grip, step, pull, push. The key was to climb the corner of the pyramid, because it presented the largest area to stand, and to concentrate intently on the rocks immediately in front of your face. No looking up, and *certainly* no looking down. A pyramid without a view.

After about forty-five minutes, each layer became higher and narrower, and I could feel the inexorable tug from the top. My pace quickened. I ignored the ache in my thighs. And finally I bounded the last few rocks to the top and raised my hands like a victorious prizefighter. I had reached the summit of one of the oldest tombs in the world. I had surmounted my fears. And before I collapsed in exhaustion, I peered over the edge

and saw nothing but the knife's blade of each layer of stone.

"You mean I have to go down?"

My journey to the lands of the Bible had begun accidentally, in Jerusalem, nearly eight years earlier. A native of the American South, I had grown up reading the stories of the Bible. But after I left home, attended college, and spent years living abroad, the Bible had grown abstract to me, its lessons far removed from my life. The more I traveled, however, the more I felt the Bible popping up around me, from world events to lines in movies. I decided I wanted to reread the Bible. I took a copy off my shelf and put it by my bed, where it sat untouched for two years, making me feel even guiltier.

Then I went to Jerusalem. On my first day, an old friend was giving a tour to some high school students and led us to a promenade overlooking the city. "Over there," my friend said, "is Har Homa," a controversial new neighborhood. "And over there," he said, pointing to the brilliant gold Dome of the Rock, "is the rock where Abraham went to sacrifice Isaac." The moment felt like one of those bolts of lightning from a Cecil B. DeMille movie. "You mean these are real places," I thought, "that you can touch, and visit, and feel?"

I had an idea. What if I retraced the Bible through the desert and read the stories along the way? What if I went to sites where the stories occurred and tried to figure out whether the events could be proven? What if I entered the stories as if they were alive and tried to become a part of them?

What if I walked the Bible?

Few people thought this was a good idea. Everywhere I went, people tried to talk me out of it.

"Most of those places are unsafe." "Many of them are in war zones." "There's no archaeological evidence that any of these events ever took place." And all that was before I told my mother. But I went back to Jerusalem six months later and met Avner Goren, the prominent Israeli archaeologist. In his fifties with squiggly gray hair and a Buddha-shaped belly, Avner was an adventurer and a romantic. He was also deeply knowledgeable; he had served as the chief archaeologist of the Sinai between 1967 and 1982. We met at a coffee shop. "I don't think you're crazy," he said. "I think it sounds fun."

"Oh, thank God," I said. "Somehow I knew you would. And by the way, would you come along?"

Months later, the two of us set out on our journey. It took the better part of a year, across ten thousand miles, three continents, five countries, and four war zones. We began in extreme eastern Turkey, on the banks of the Tigris and Euphrates rivers, looking at the earliest stories of Genesis and their connections to Mesopotamia. We continued to Mount Ararat, where Noah's ark lands, and traveled to Harran, one of the oldest cities on earth, where God first calls Abraham to set out for the Promised Land.

From Turkey we headed south into Israel and the Palestinian Territories, exploring the tales of the patriarchs—Abraham, Isaac, and Jacob. We ventured deep into the Galilee, where Abraham first stops upon reaching the Promised Land, tracked down the lost cities of Sodom and Gomorrah, and hiked to the holiest spot in Jerusalem, where God

calls Abraham to sacrifice his son. In Egypt, we ventured down the Nile, investigating how Joseph, sold into slavery by his brothers, manages to become prime minister of the greatest empire in the world. And in the plush Delta region north of Cairo, we surveyed the land where Moses is born, and attempted to cross the actual body of water where he leads the Israelites into freedom.

The Israelites' forty years in the desert proved to be the most dramatic part of our trip, as we located the possible source of biblical manna, came face-to-face with the purported burning bush, and climbed to the top of the mountain where Moses is said to have received the Ten Commandments. But as we moved toward the climax of our travels, I began to realize that my emotions had changed. I was less interested in proving the stories—finding the actual rock, stream, or mountain—and more interested in uncovering the meaning of the stories.

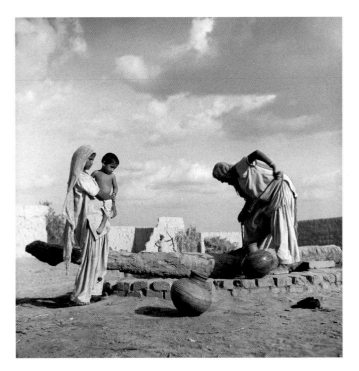

Women washing laundry along the Nile.

One of my favorite moments in the Bible occurs in the Book of Numbers. After the Israelites receive the Ten Commandments and set off to the Promised Land, Moses sends twelve spies to scope out the strength of the enemy the Israelites must confront. The spies visit Hebron, in the hills south of Jerusalem, and ten of the twelve report back that the enemy are giants who would easily withstand an attack from the Israelites. (The only two who favor God's desire for an assault are Joshua and Caleb.) The people grow angry and ask God to send them back into slavery in Egypt. God's response is telling: He doesn't wipe them out or exile them back to Egypt. He sentences them to *two generations in the desert*. By his very action, God seems to indicate that only by being in the wilderness will the Israelites shuck the bad habits and values they picked up in Egypt and become the people he wants them to become.

The best way to understand God is to understand the land.

Walking the Bible was published in March 2001 and became that fantasy all writers have of writing a book that touches people around the world. On a

whim, in the weeks before the book was released, I established a website and invited people to write in with their responses. In the subsequent months, I was overwhelmed with the outpouring of notes I received. People wrote minutes after closing the book, or in the middle of the night two weeks later, with the most immediate and intimate responses to my journey. Without question, the number one query I received from readers was, "Do you have any pictures?"

This book is the answer to that question.

For as long as I can remember, I have traveled with a camera. Photography was a central part of my childhood. My father has been a serious amateur photographer since the 1950s, and a regular ritual of my youth was gathering in the living room to watch slide shows of his travels in the navy. My mother, a painter and art educator by training, took up photography in the 1980s, and my older brother won his first photography award while he was still a teenager. By the time we began taking family trips abroad together as adults, the dominant image I have of us is five people—including my younger sister—fanning out in a new place with camera bags on our backs.

As a writer, I've always felt at particularly intense moments of travel that my eyes and ears go into a kind of sensory overdrive, sucking in information from the scene around me. For me, the camera helps that process. It's like an extra eye, which allows me to see things—patterns, color, light—that my normal eye, even my writerly eye, would not see. I am often struck, when reviewing slides after a trip, that the images form their own

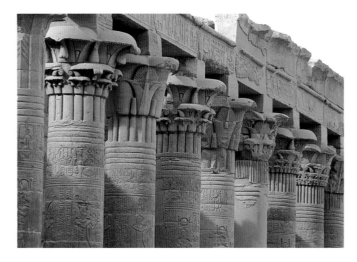

Columns in Luxor Temple in Upper Egypt.

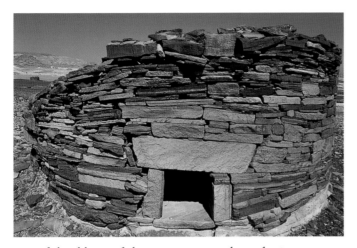

One of the oldest roofed structures on earth, in the Sinai.

narrative, which is nowhere near the narrative I might tell with words. For me, a picture is not worth a thousand words, or even ten thousand. Its real worth is what it captures that is beyond words.

The 150 images in this book were culled primarily from the thousands of pictures I've taken in over a dozen trips to the Middle East in the last decade. They are supplemented with a few images taken by my brother, Andrew Feiler, and a number from private collections of photographers much more talented than I. My goal in assembling them here is to revisit the familiar stories of the Bible with a slightly different eye—to take these beloved stories out of their black covers and their gilt-edged pages and replant them in the ground. For to me, the process of gathering these images was a reminder of the Bible's effortless ability to reinvent itself for each generation and each new way of searching.

Sitting atop the pyramid that winter morning, I couldn't help thinking that these magnificent wonders of the ancient world once represented the pinnacle of religion in the greatest empire on earth. Today that religion is dead. Yet the Bible still lives. Why? Because the Bible takes the best of Mesopotamian religion, combines that with the best of Egyptian culture, and introduces the notion of an abstract, universal God. That singular idea changed the world and allowed the Bible to endure, in a realm beyond pictures and beyond even words.

IN THE BEGINNING

The biggest commodity in the Middle East is not land, it's water. And it has always been that way. The most important revolution in the history of the world—the agricultural revolution—occurred around ten thousand years ago, when for the first time humans stopped wandering from place to place and started to settle in one area. That occurred first in Mesopotamia and Egypt, the two ends of the Fertile Crescent, where early farmers began to cultivate rivers, build canals, and develop agriculture. With irrigation, farmers needed laws; with laws they needed writing; with writing they needed education. Civilization began to develop. The most influential—and the most beautiful— piece of writing to emerge from that time was the Bible. Its opening verses drip with references to water. The Garden of Eden is built at the confluence of four rivers—the Tigris, the Euphrates, and two that are unknown. The Flood represents a world where the annual inundation of rivers was vital and unfathomable. Even the opening verse of Genesis contains references to water. "When God began to create the heaven and the earth—the earth being unformed and void, with darkness over the surface of the deep and a wind from God sweeping over the water—God said, 'Let there be light.' " The Hebrew word for deep, *tehom*, means "sea monster." In Mesopotamia, chaos was represented by a sea monster, Tiamat. Tiamat is the root for *tehom*. We're only in the first line, and already the Bible is saying, "These stories didn't happen just anywhere. They happened here. In Mesopotamia."

The Euphrates (*opposite*) and the Tigris are two of
the four rivers that flow in the Garden of Eden.

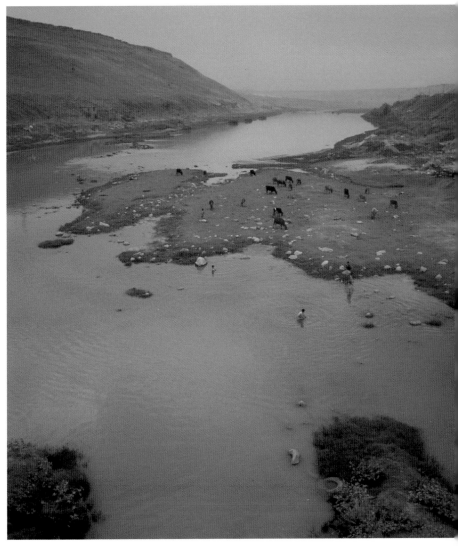

The Tigris and the Euphrates (*left and above*) are not long, as rivers go. The Euphrates, whose name means "sweet water," covers 1,740 miles, making it the twenty-eighth-longest river in the world. The Tigris, whose name means "fast as an arrow," stretches 1,180 miles, the fifty-fourth-longest river in the world. But they are strategically placed. They begin in eastern Turkey, 50 miles from each other, and converge near Baghdad, where they are 20 miles apart. They diverge again, before meeting in Qurnah, 200 miles southeast of Baghdad, whereupon they flow together into the Persian Gulf.

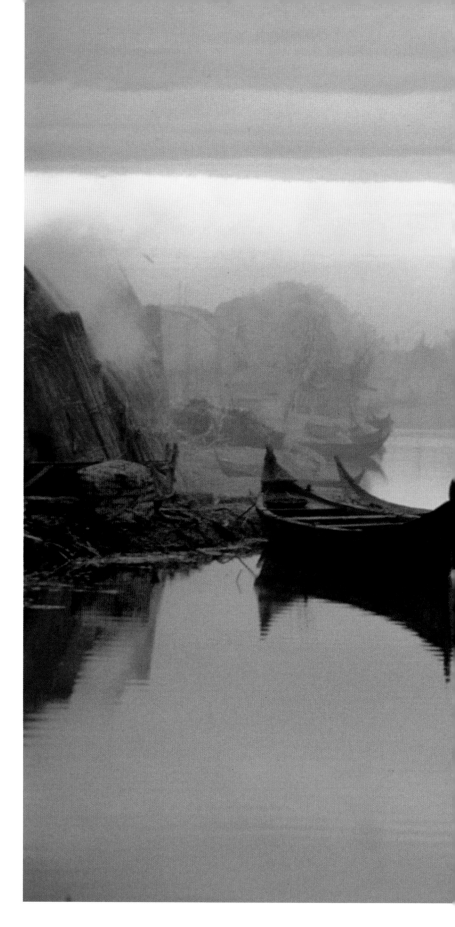

Water played a vital role in ancient creation stories. The earliest stories date from the third millennium B.C.E. and come from Sumer, in today's southern Iraq. The root of the Sumerian worldview was a primeval sea, which later divided into a vaulted heaven superimposed on a flat earth, an idea almost identical to Genesis. The Babylonian creation story, also from ancient Mesopotamia, is even closer to Genesis. In the story, the world is presented as a watery chaos, which a god slices in two, creating heaven and earth. The chief god then creates, in succession, light, the firmament, dry land, heavenly lights, animals, and man. Afterward he rests and celebrates with a banquet. The similarities to the biblical account are striking.

BRUCE FEILER

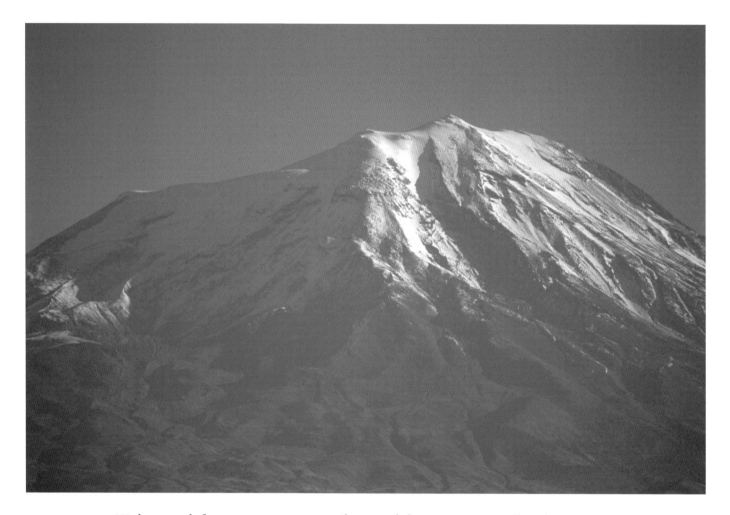

With so much focus on rivers, it was only natural that ancient storytellers fixate on floods. The Bible gets to the topic in the sixth chapter of Genesis. After the Garden of Eden, God grows frustrated with humans and vows to blot them out. He asks Noah, a righteous man, to build an ark out of gopherwood, divide it into three decks, and fill it with animals. In the six hundredth year of Noah's life, the fountains of the deep burst apart, and it rains for forty days and nights. After seven months on the water, the ark comes to rest on "the mountains of Ararat." As with Creation, the story of Noah fits into an extensive tradition. Flood stories appear in 217 cultures around the world. But unlike Creation, the Flood story is the first part of Genesis that can be located with any degree of certainty. In far eastern Turkey, on the border with Armenia and Iran, a huge abandoned volcano rises from the mountains. Mount Ararat (*above and opposite*) is a perfect volcanic pyramid 16,984 feet high, with a junior volcano, Little Ararat, attached to its hip. Mount Ararat is the tallest mountain in the Middle East and is a thousand feet taller than Mont Blanc, the tallest mountain in the Alps.

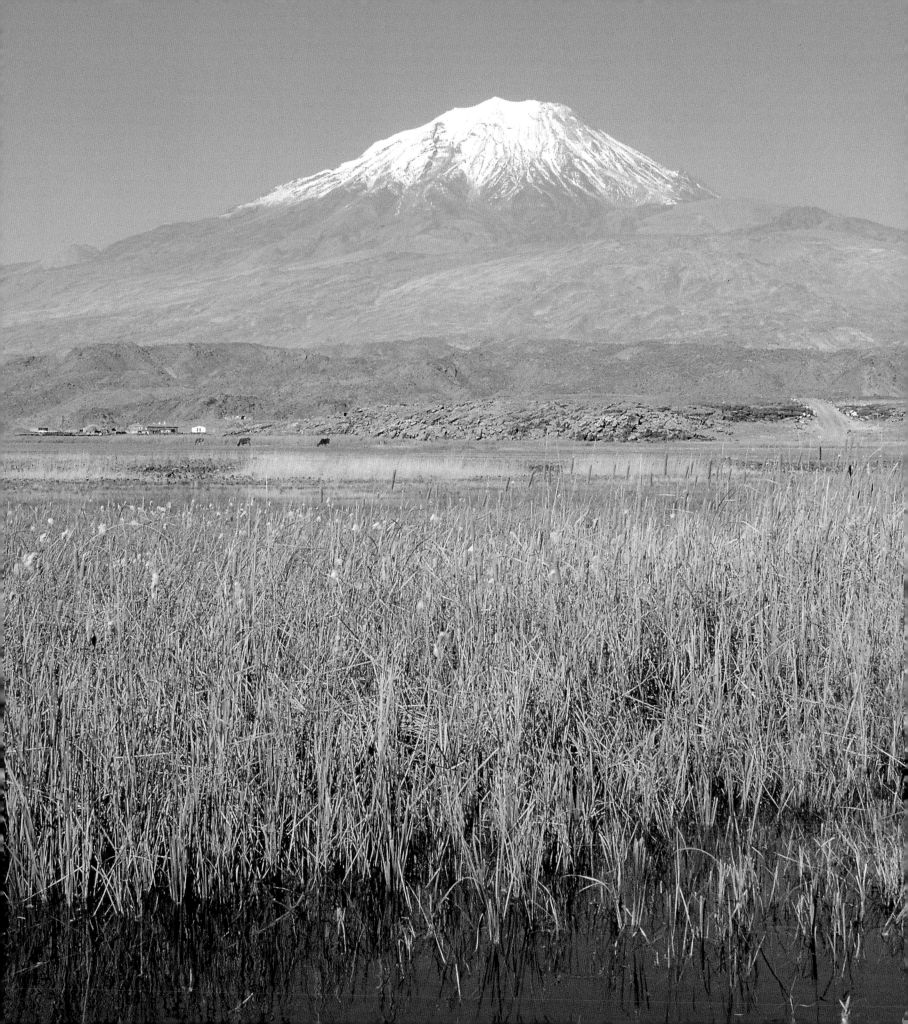

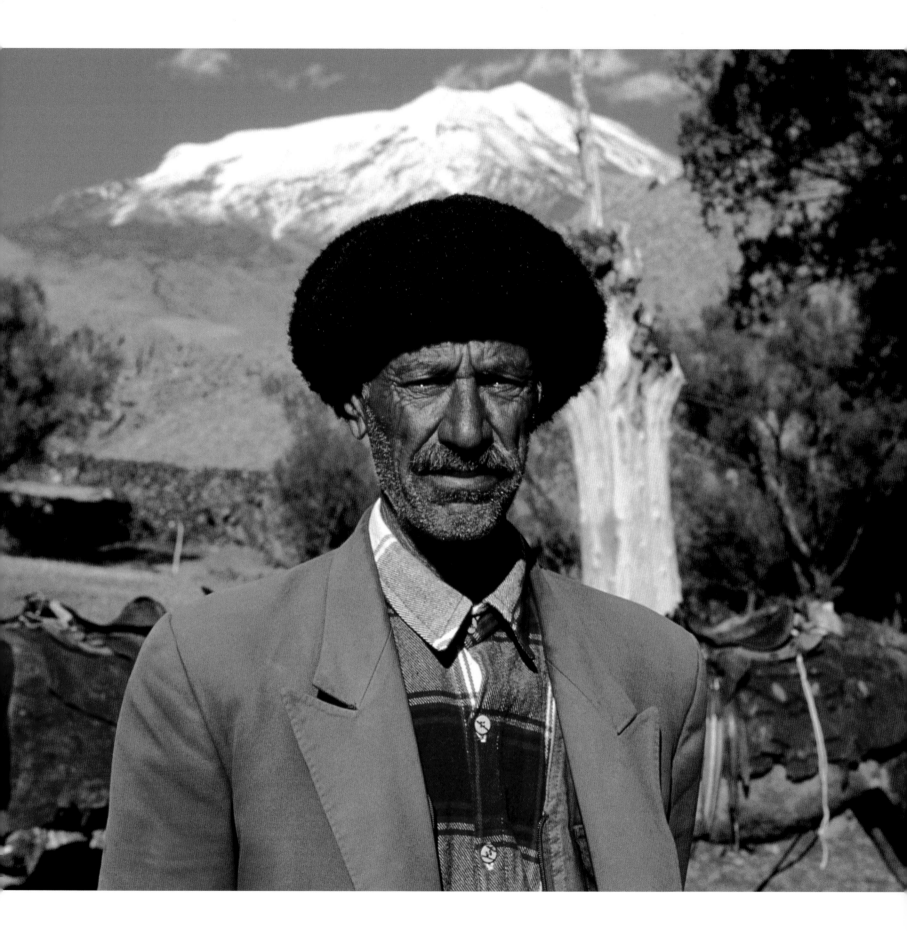

Stories of sightings of Noah's ark have been a staple of Near Eastern lore for millennia. Josephus, the first-century historian, wrote of legends that the ark landed "on a mountain in Armenia." By the nineteenth century, the sightings grew more elaborate. In 1887, two Persian princes wrote that they saw the ark while on top of Ararat, which is covered in snow year-round. In 1916, two Russian pilots claimed they saw the ark from the air, and the following year Czar Nicholas II sent two expeditions. His daughter Anastasia is said to have worn a cross made of ark wood. Most photographs of the ark have similarly disappeared, including some taken by American U-2 spy planes in the 1950s. Even Air Force One is said to have played a part; during a flight to Tehran in 1977, while Jimmy Carter was traveling to visit the Shah, a UPI photographer claimed he saw a large, dark boat.

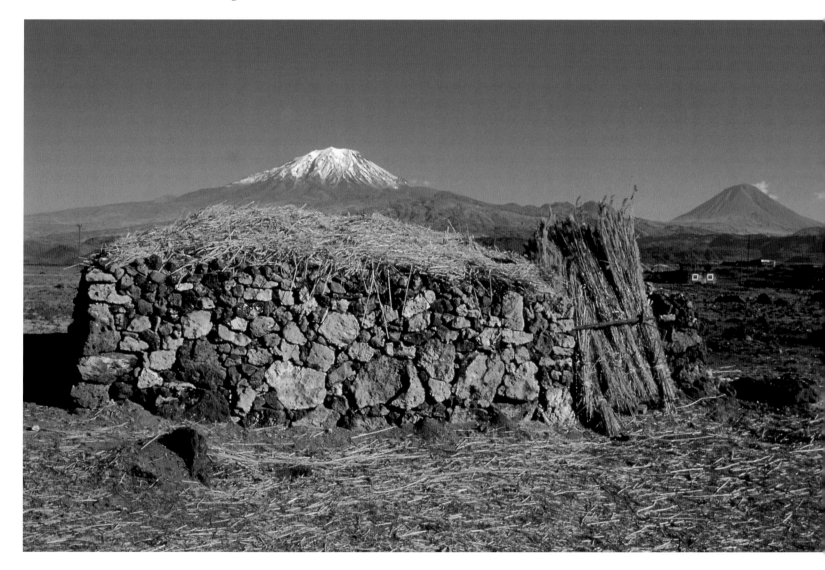

Halfway up Ararat, the scene is pastoral, the view of the top even more daunting than that from below. The people who live on the side of the mountain speak of the ark as if it were built just yesterday. They teach their children that some will have the luck of Noah, some will not. Standing on that mountain, I was most struck that the spirit of the story still lives in these hills, five thousand years after it was first told. Maybe proving the story was far less important than discovering its ongoing presence.

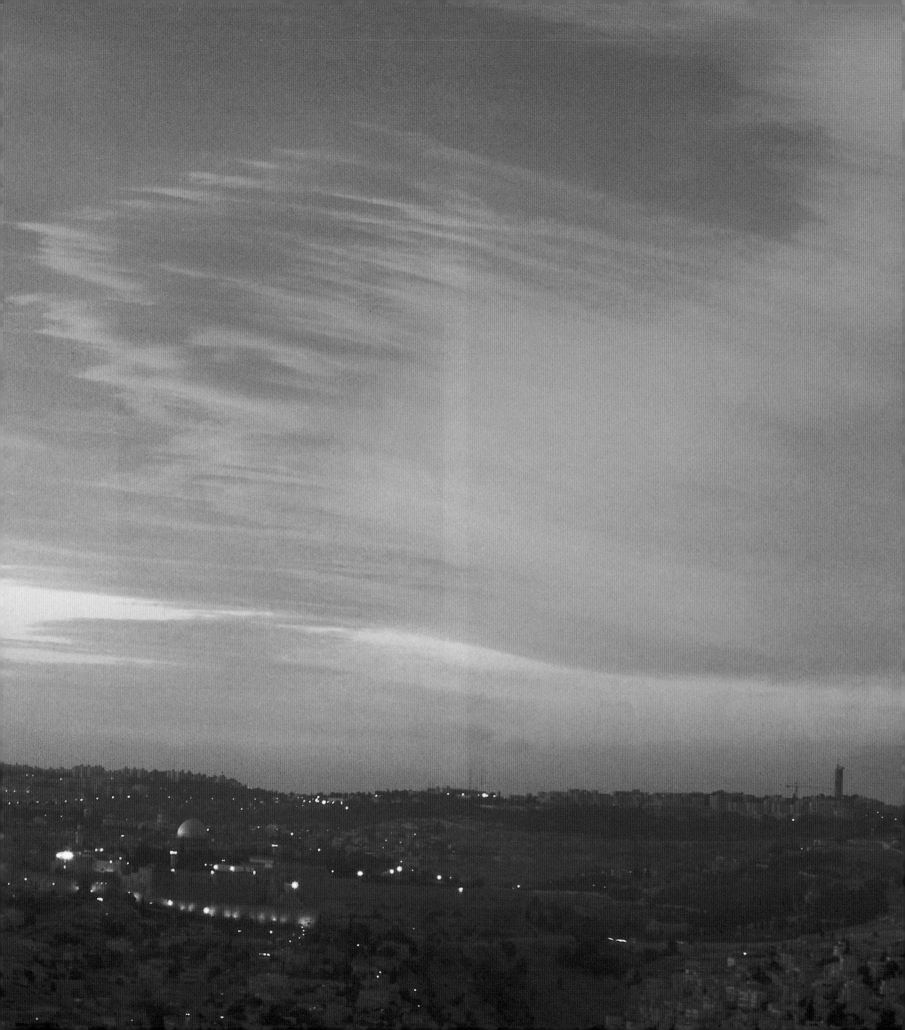

THE PATRIARCHS

The relationship between humans and God in the Bible unfolds with pulse-quickening suspense and mathematical regularity in the Book of Genesis. Adam and Eve are created in the first week of Creation, but God is disappointed with their refusal to follow his commandments and kicks them out of the Garden of Eden. Nine generations pass between them and Noah. Noah builds the ark and saves the animals but then starts drinking, the Bible says. Once again God grows frustrated and withdraws. Nine more generations pass between Noah and Abraham. Finally, with the seventy-five-year-old, childless Abraham, God finds the human partner he has been seeking since Creation. The moment when God calls out to Abraham in Genesis 12 is one of the most arresting in the entire Hebrew Bible. "Go forth from your native land," God says, "and from your father's house, to the land that I will show you. I will make of you a great nation, and I will bless you. I will bless those who bless you and curse him that curses you; and all the families of the earth shall bless themselves by you." Abraham's decision to accept this tempting, yet demanding, offer secures his reputation for all time. It also defines the remainder of the biblical era as it establishes the central relationship at the heart of the story: the sacred bond among the people, the land, and God. Land is the most overlooked and misunderstood of these components. The land is not a destination unto itself; the land is a catalyst where humans and God can live in consort with one another.

In the mornings and evenings, Jerusalem is
bathed in the most incandescent sunlight.

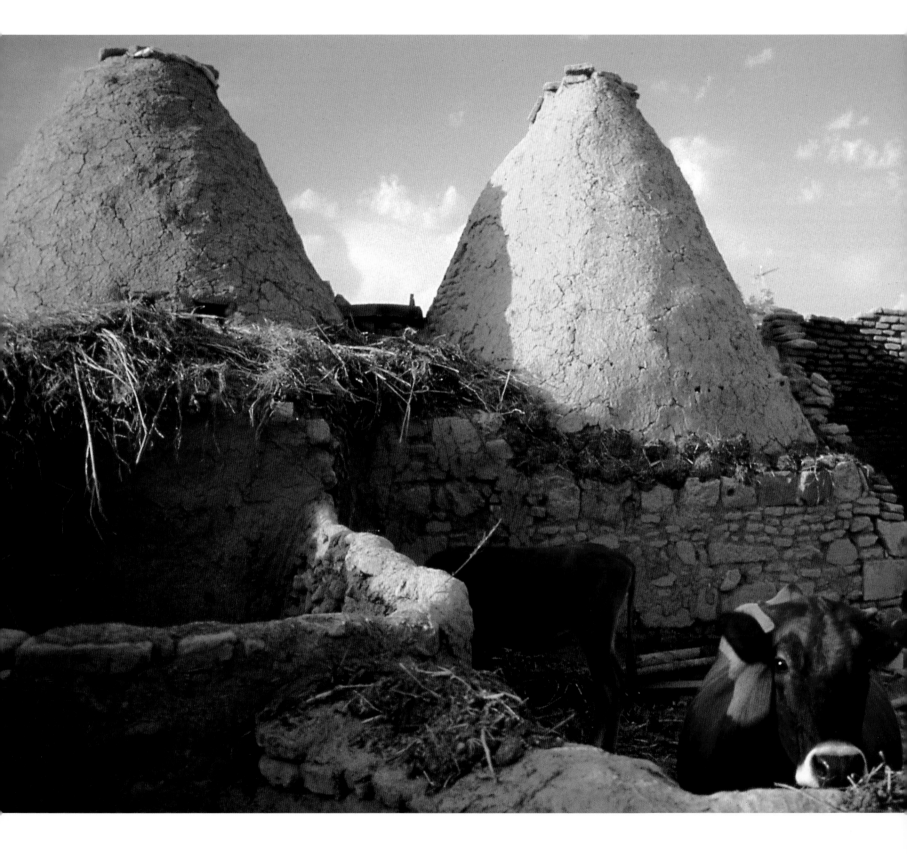

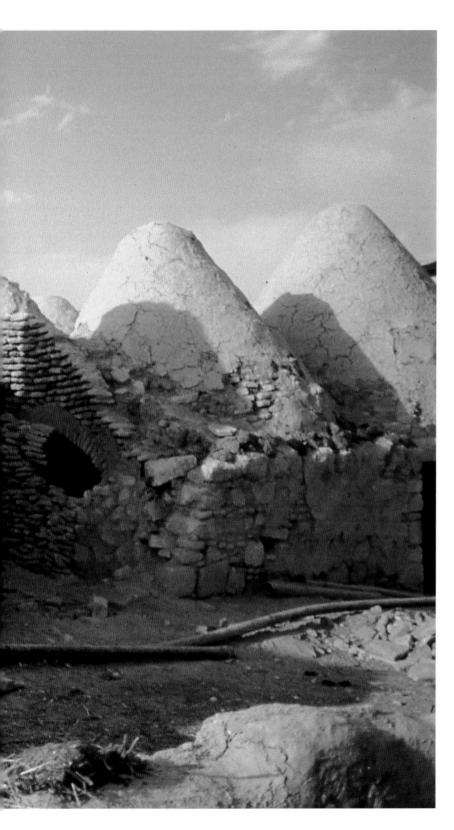

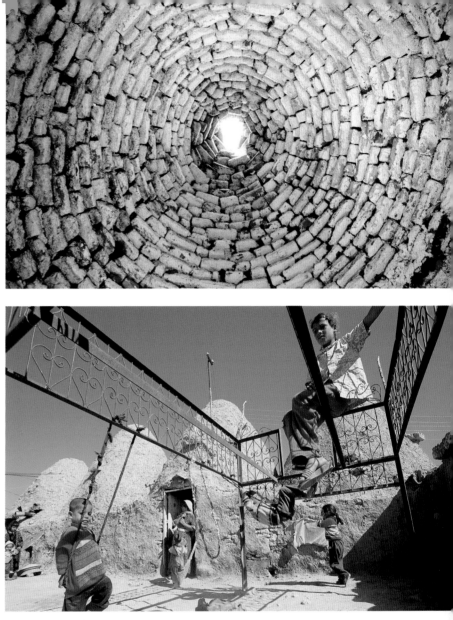

When we first meet Abraham, in Genesis 11, he is living in Ur of the Chaldeans, which seems to suggest the capital of ancient Sumer, called Ur, located in southern Iraq. Consistent with his lifestyle as a pastoral nomad, Abraham (he's still called "Abram" at the moment; God changes his name later) proceeds with his family north, through the Mesopotamian Valley, until he reaches Harran. One of the oldest cities on the planet, Harran, in southern Turkey today, has been mostly abandoned for centuries. A small village now sits near the ruins, with mud-brick houses built with domed roofs (*left and above*), which are designed to take the heat and funnel it away from the ground.

Harran is an ancient, deeply moving place. It contains ruins from the second millennium B.C.E. (likely after the time of Abraham) and a decayed Crusader castle (*above and right*) excavated in the 1910s by T. E. Lawrence, the future Lawrence of Arabia, while he was still a student at Oxford. Driving to the site, on a road so straight it seemed to have purpose, I felt a strong pull from the flat, dusty landscape. The Hebrew word for earth is *adama*, the same root used in Adam. "From dust you are," God says to Adam, "to dust you shall return." The Bible seems to suggest we come from these places, and we carry these places around within us.

The Lord said to Abraham,

"Go forth from your native land and from

your father's house, to the land that I will

show you. I will make of you a great nation,

and I will bless you."

GENESIS 12:1–2

When Abraham leaves Harran and heads to the
Promised Land, he also leaves the land of rivers and
heads to a less fertile, more vulnerable place. But he
does so based on the word of God, who by promising to
make Abraham a great nation, gives Abraham the power
of creation that before only God had possessed.

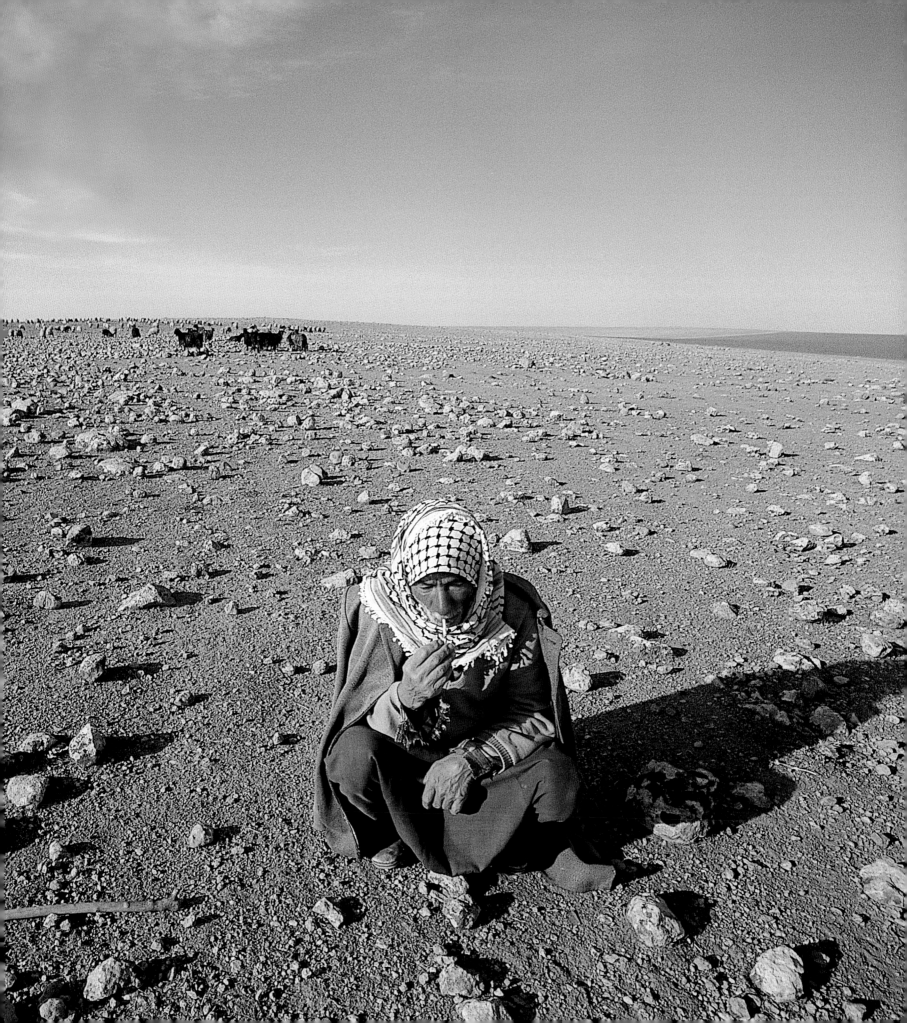

The Journey of Abraham

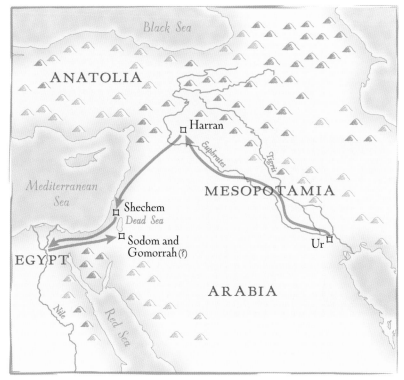

The Bible doesn't say how Abraham traveled from
Harran to the Promised Land. The chief trade routes of
the early second millennium B.C.E. moved south through
Damascus into modern-day Jordan, then crossed into
ancient Canaan, today's Israel and Palestinian
Territories, just south of the Sea of Galilee (*left*) and near
Jericho. The Fertile Crescent was structured like a
modern American shopping mall, with an anchor store
on either end—Mesopotamia and Egypt—and more
vulnerable boutique stores in the middle. Canaan was
not a unified empire but an informal amalgamation of
city-states that were easily overrun by outside forces.

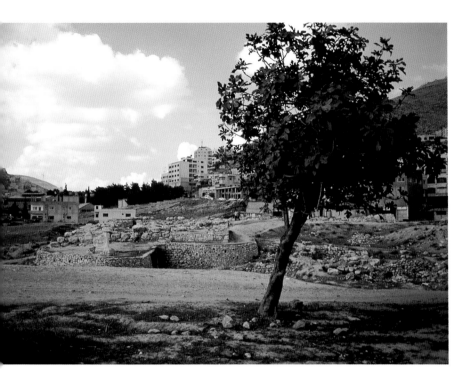

The strongest cities in Canaan were located near lots of water, either along the Mediterranean or at the base at the central spine of mountains (*right*). Abraham stops first near the ancient city of Shechem (*above*), in modern-day Nablus. Alongside a terebinth, or oak, tree, Abraham builds an altar to God, who renews his promise to give this land to Abraham and his descendants. The site today is ringed by a modern city. Abraham then proceeds southward, to Bethel, Gerar, and Hebron, all mountainous cities. As a pastoral nomad, Abraham would not have wanted to stop alongside the strongest cities and risk possible conflict, which may explain the route he took, down the less-developed area of the countryside. As part of a small, wandering family, he still wanted to limn the outer edge of civilization.

I will bestow my blessing upon you

and make your descendants as numerous

as the stars of heaven

and the sands on the seashore.

GENESIS 22:17

Israel today is a land of dramatic variations, a country
one quarter the size of Scotland with as much geographic
diversity as the British Empire at its peak. The terrain
stretches from plush mountains in the north, through
terraced hills in the center (*following pages*), to the
beautiful bleakness of the Negev (*right*) in the south.
The patriarchs face this entire scope, as Abraham first
settles in the fertile northern hills, then travels as far as
the Negev before confronting a famine that sends him
fleeing to Egypt.

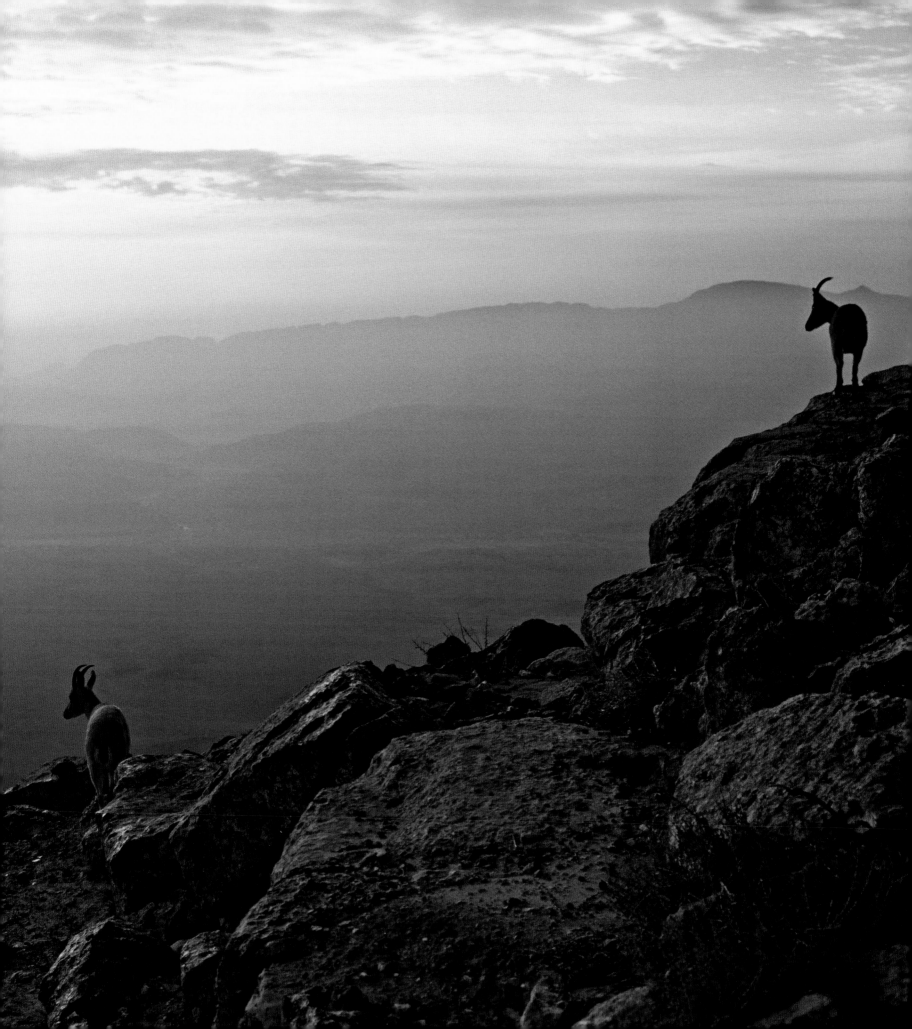

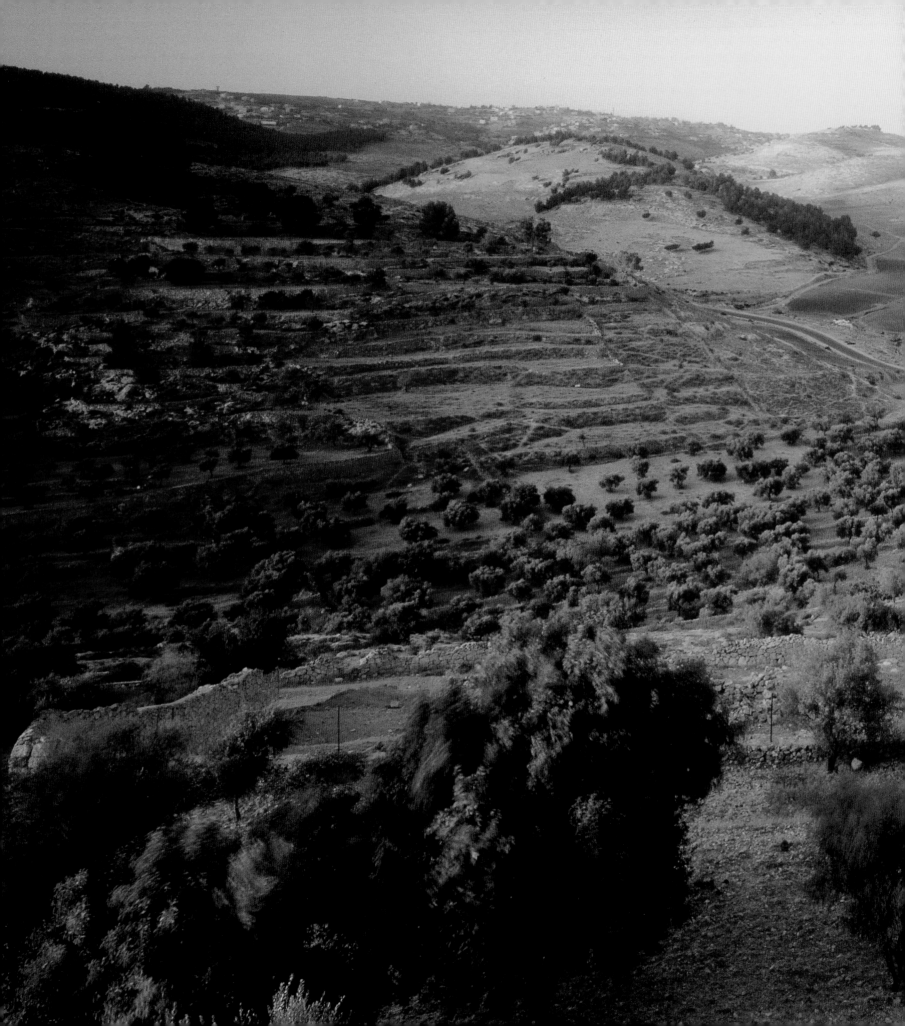

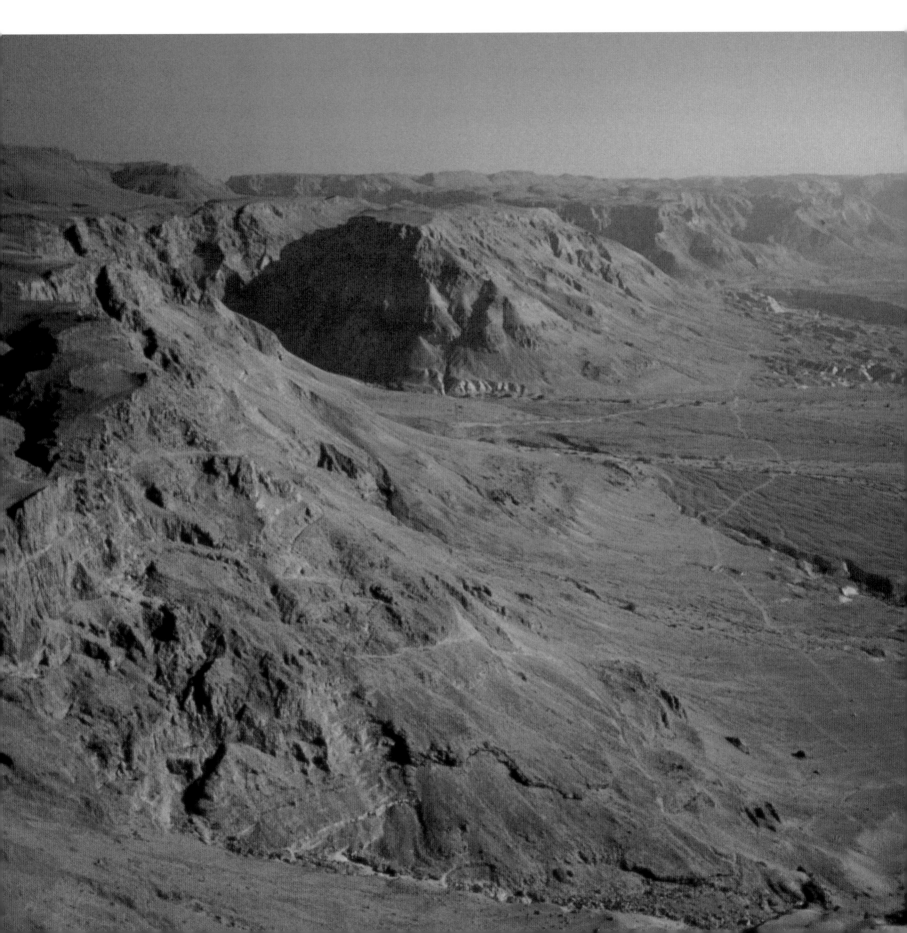

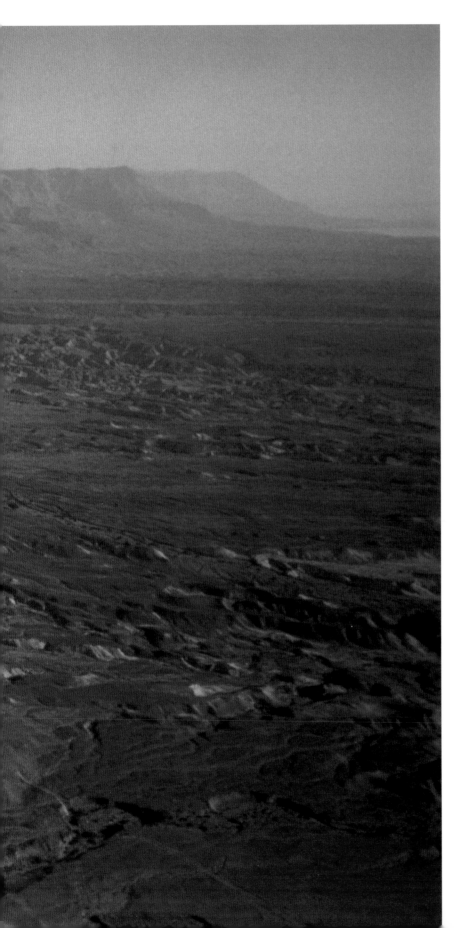

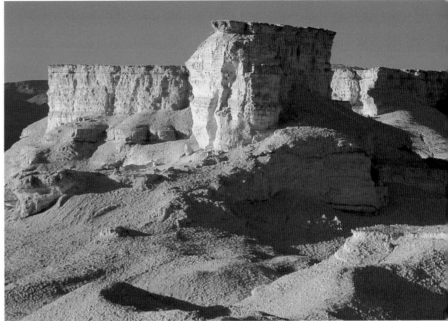

During Abraham's sojourn in Egypt, he fattened his entourage—and his coffers. Returning to the Promised Land, Abraham decides the time has come to ask his prosperous nephew, Lot, to split from the family. Abraham offers Lot his choice of land, and Lot chooses some fertile ground along the border with Jordan, near the bottom of the Syrian-African Rift. A giant scar across the face of the earth, the Great Rift Valley stretches from Lake Victoria in Central Africa, up through the Sinai, all the way to the Euphrates. Caused by an earthquake two million years ago, the Rift reaches its bottom along the border with Israel and Jordan (*left and above*), at the Dead Sea.

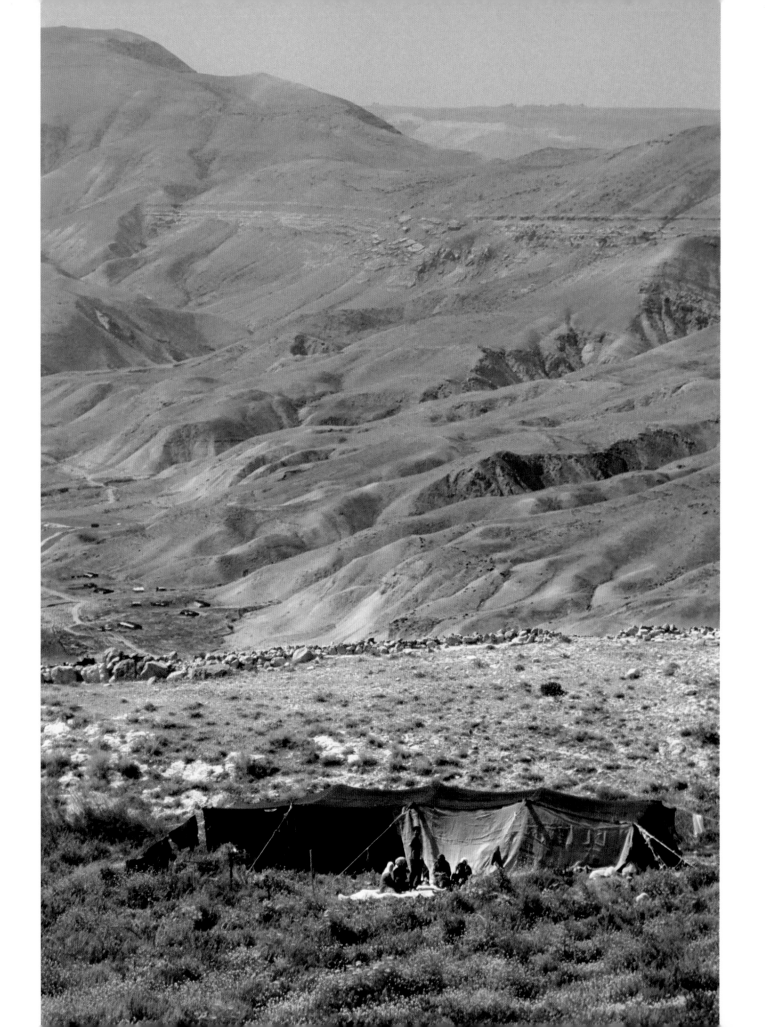

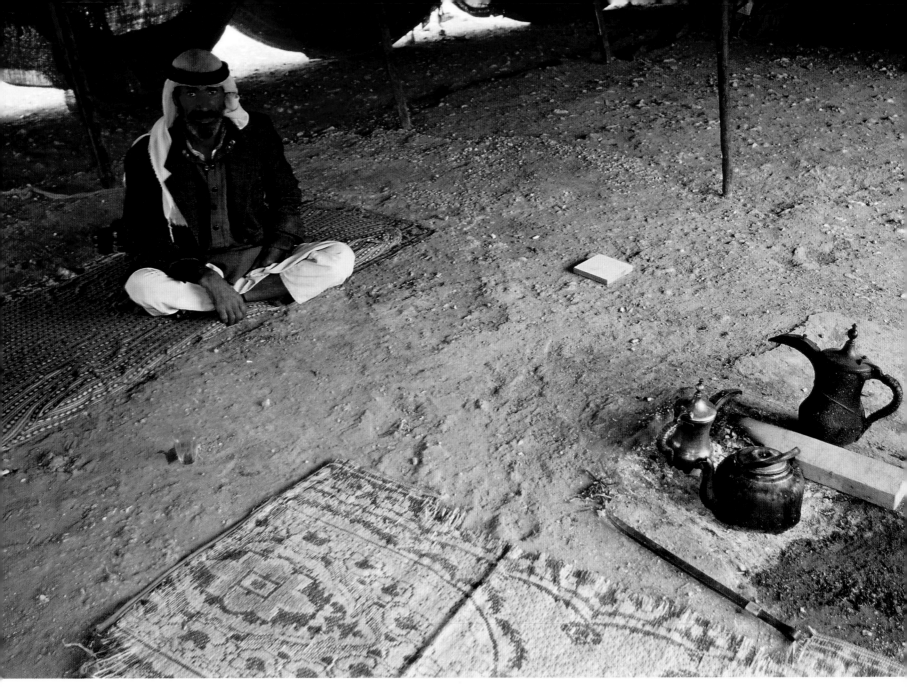

Decades after God promised to make the childless Abraham the father of a great nation, the patriarch still has no son. His wife, Sarah, follows Near Eastern custom and offers him her Egyptian maidservant, Hagar, who gives birth to Ishmael. One day, when Abraham is sitting at the entrance of his tent, like bedouin tents of today (*opposite and above*), the Lord visits in the guise of three men. Abraham, following bedouin tradition that hospitality is a sacred trust in the desert, orders that they be given food and water. "My lords, if it please you, do not go on past your servant. Let a little water be brought; bathe your feet and recline under a tree." Abraham hastens to Sarah and asks her to prepare a meal of choice cakes and curd. He then slaughters a calf and serves it, too.

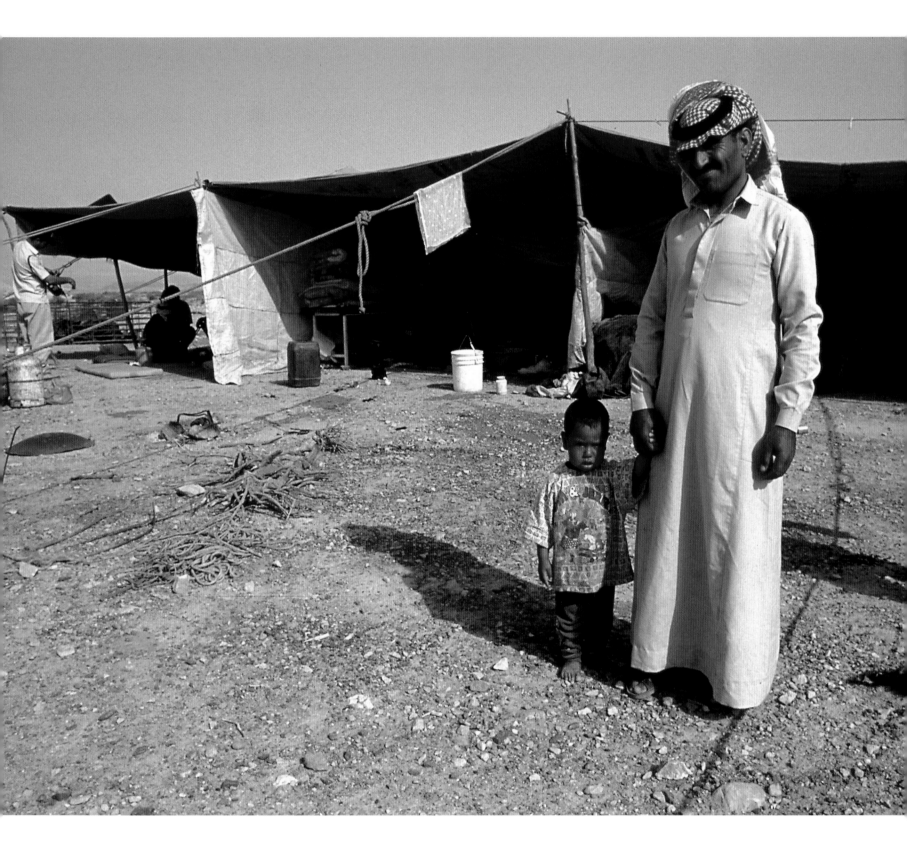

Bedouin tents are divided into at least two areas—one for men, one for women—and sometimes one for visitors. This setup, still used today, is vividly apparent in the memorable showdown in Abraham's tent. After the messengers of God eat, they ask Abraham where his wife, Sarah, is. Stuck in her side of the tent, she is not allowed to greet the men. After Abraham answers, one of the men announces, "I will return to you when life is due, and your wife Sarah shall have a son!" Sarah, who is then ninety and listening from behind the flap, laughs out loud. "Why did Sarah laugh?" the men ask. Sarah grows frightened and denies she laughed, but the men repeat, "You did laugh."

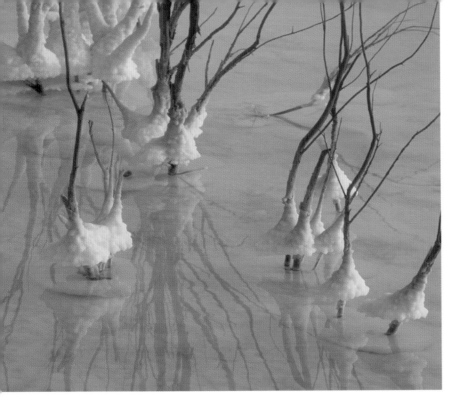

Before leaving the tent, the men announce their intention to destroy Lot's home, in Sodom and Gomorrah, for its sins. The location of these cities has long been a mystery, but perhaps no more. At 1,300 feet below sea level, the Dead Sea is the lowest spot on earth. The water is 25 percent solids, six times saltier than the ocean. The atmosphere pushes down on the water, which in turn pushes down on several miles of salt deposits, squeezing out the salt. The salt is forced deeper into the earth and eventually out toward the shore, at which point it pushes up through the ground into assorted asparagus-like formations (*opposite*). Israeli schoolchildren call these formations "Lot's wife."

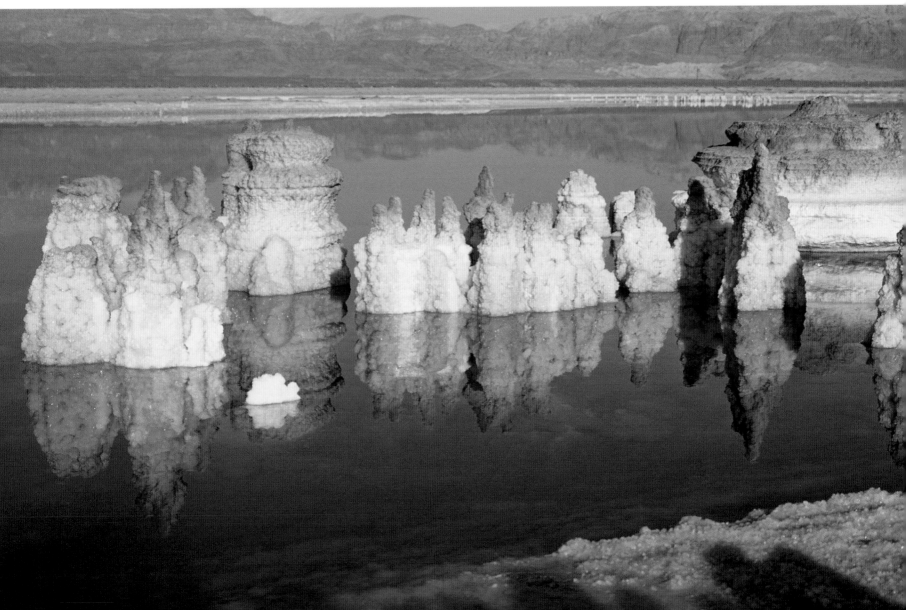

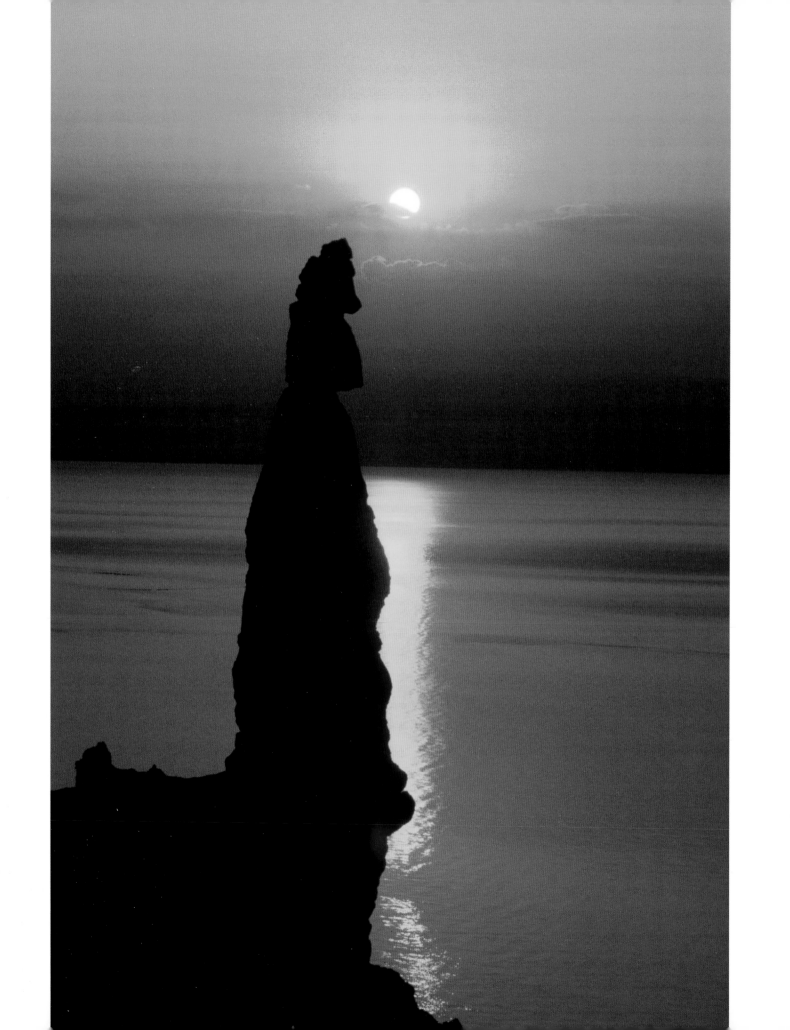

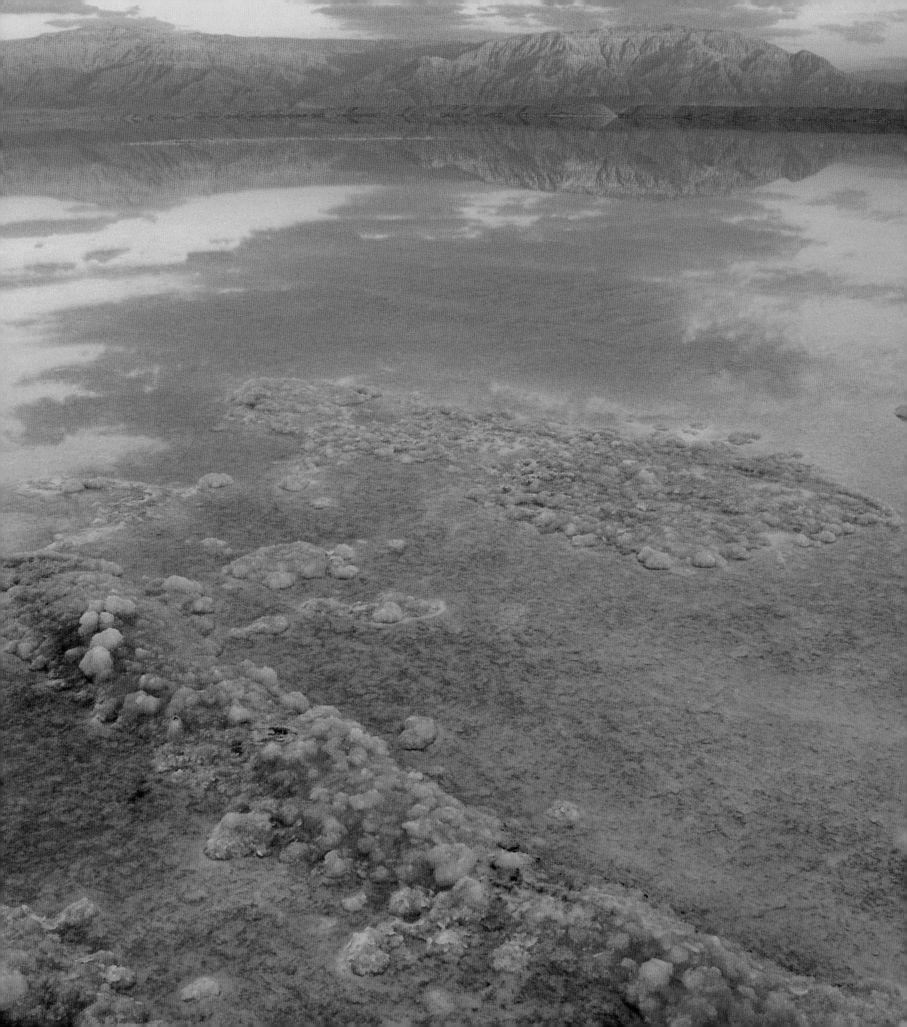

Before God destroys Sodom and Gomorrah, he instructs Lot and his family to flee but not to glance behind them. When Lot's wife does look back, she becomes a pillar of salt. Standing at the Dead Sea, I realized that reading the Bible in the places certainly changed my opinion of the stories. But it also changed my opinion of the places. The Bible is a book of faith, a book of characters, a book of God. But it also may be the greatest guidebook ever written.

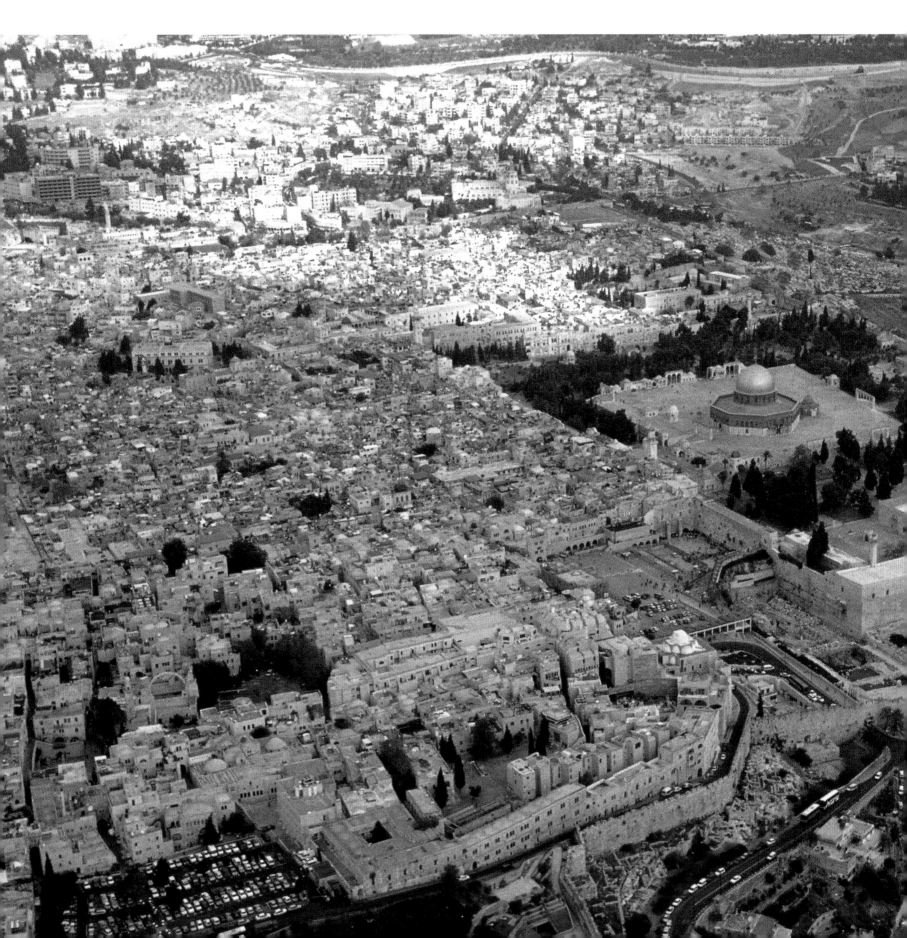

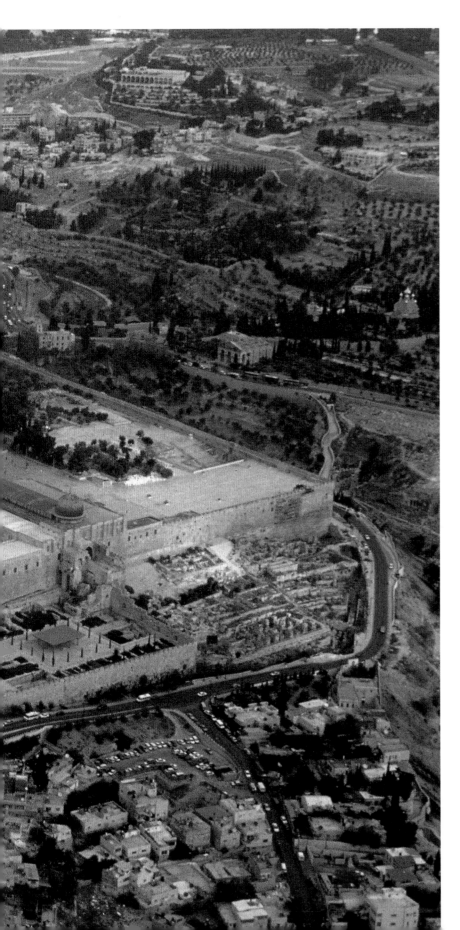

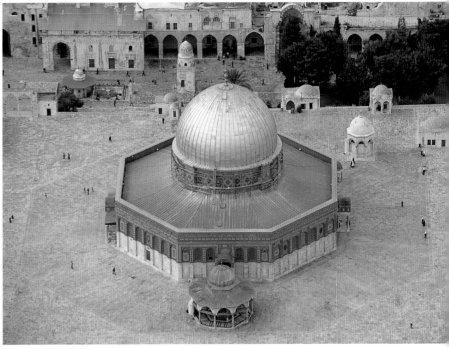

Genesis 22 contains one of the most haunting passages in the Hebrew Bible, as God calls out to Abraham, saying, "Take your son, your favored one, Isaac, whom you love," and offer him as a burnt offering in the land of Moriah, on one of the heights that I will point out to you. As with God's earlier call to Abraham, the specific land in this commandment is unidentified. Since antiquity, the spot of Abraham's near sacrifice of his son has been linked with the eastern summit of the old city of Jerusalem (*left*), on a hill near the City of David, where Solomon later built his Temple, where Jesus walked in Herod's Temple, and where Muslims built the Dome of the Rock (*above*) to mark the spot where Mohammed made his night ride to heaven.

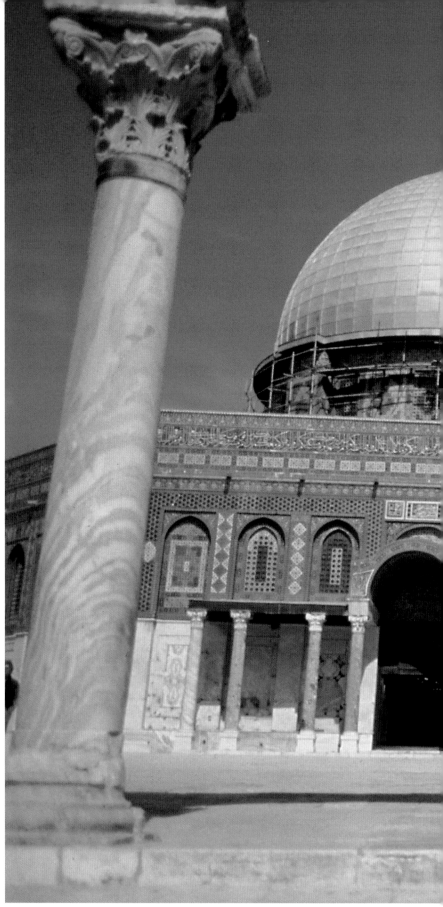

Holy to three faiths, the Temple Mount (*right*), or Haram al-Sharif in Arabic, has also become a centerpiece of violence in the Middle East, the most contested piece of real estate in the world. Though encircled by razor wire and lined with security personnel, the Temple Mount still exudes a broader truth: no camera angle, no genuflection, no prayer can take place that does not include at least two faiths.

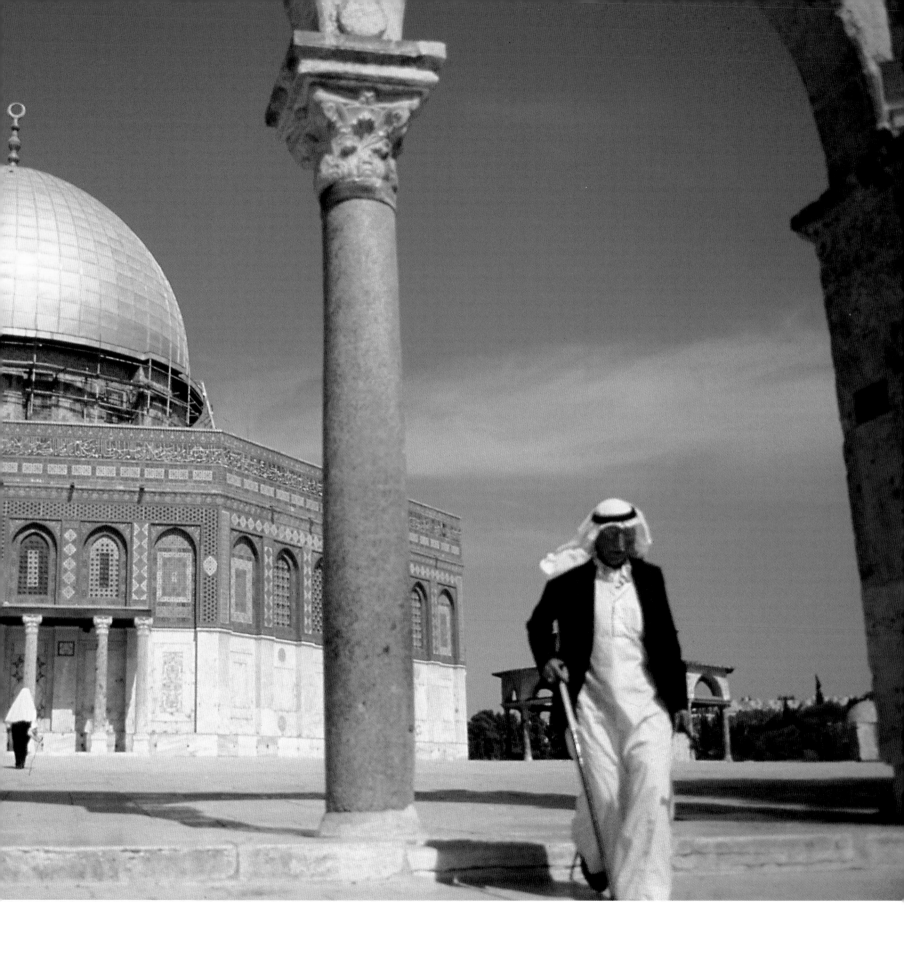

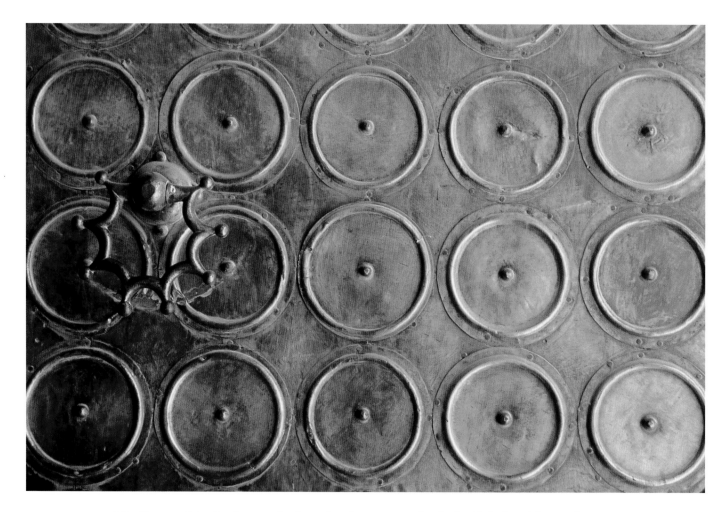

The Dome of the Rock, was built in 691 by Umayyad caliph Abd al-Malik, on the spot where the Temple once stood. Considered the jewel of Islamic architecture, the octagonal building is lined with Persian tiles the color of sapphires that contain scripts from the Koran. Double brass doors (*above*) lead to the inside, which is covered in carpets. The dome itself, which is 65 feet across and 115 feet high, was covered in lead until 1964, when it was lined with copper. In 1994, King Hussein of Jordan added a .0023-millimeter layer of 24-karat gold. Underneath the dome is an enormous piece of exposed limestone (*opposite*), the summit of the hill, 58 feet by 45 feet, that legend says is the spot from which Mohammed ascended to heaven.

BRUCE FEILER

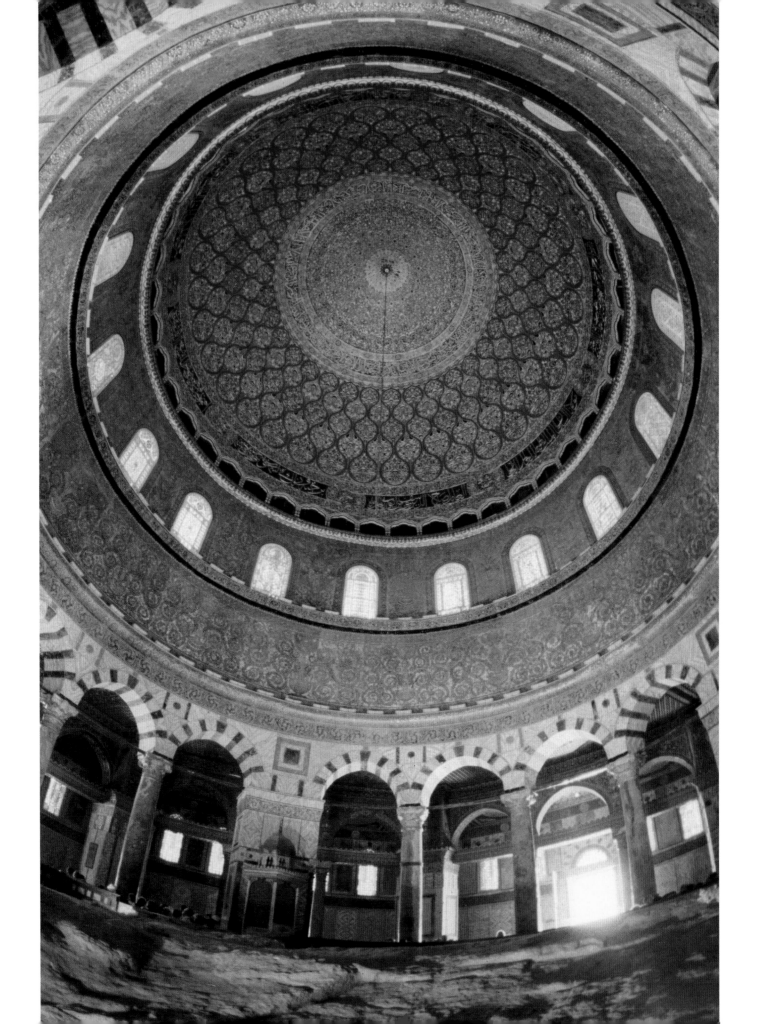

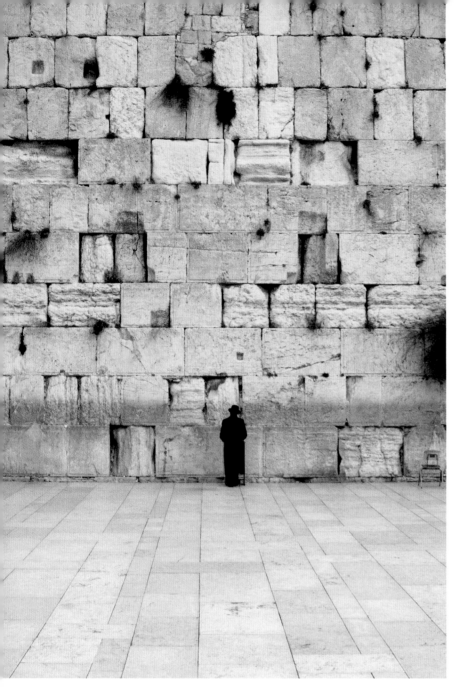

The outer wall of Herod's Temple compound, built around the Second Temple beginning in 20 B.C.E., is considered the holiest spot in Judaism. For centuries, Jews gathered to pray at the eighty-five-foot limestone facade, and beginning in 1917, it was called the "Wailing Wall" because of the sound of their prayers. But after the Israelis liberated the area in 1967, Jewish leaders renamed the twenty-four layers of stones the *Western Wall*, claiming Jews no longer weep, as their state has been renewed and their freedom of worship returned.

BRUCE FEILER

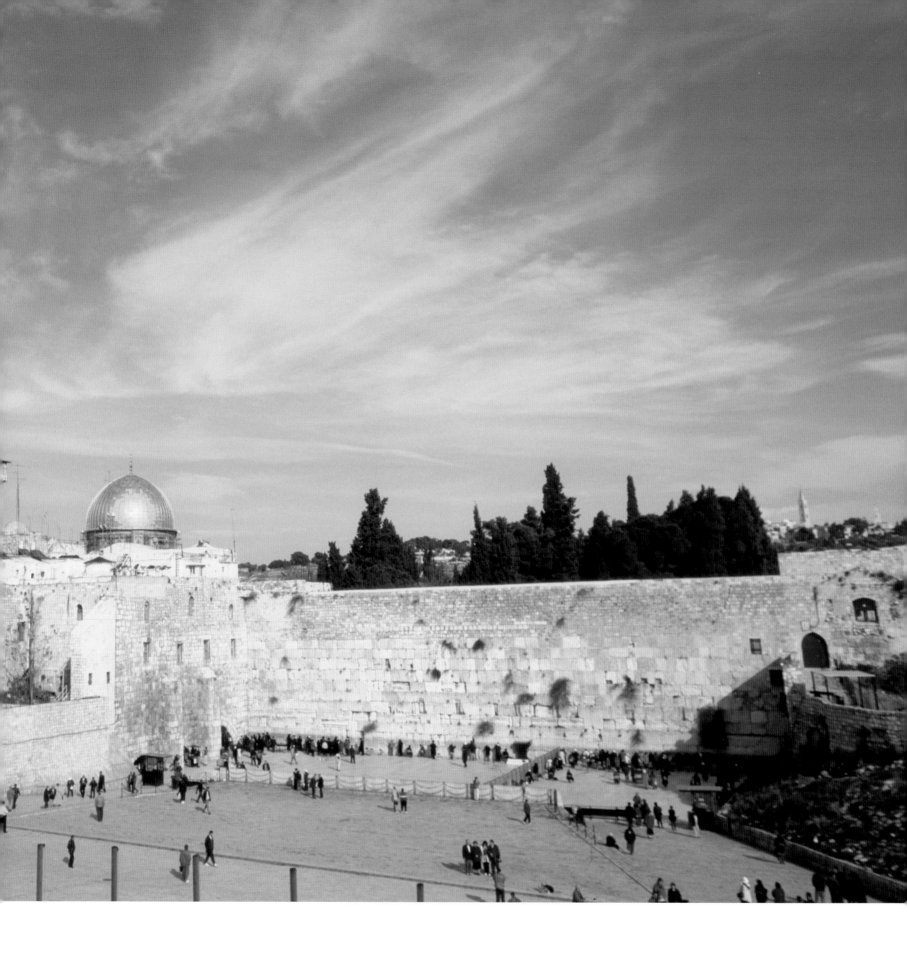

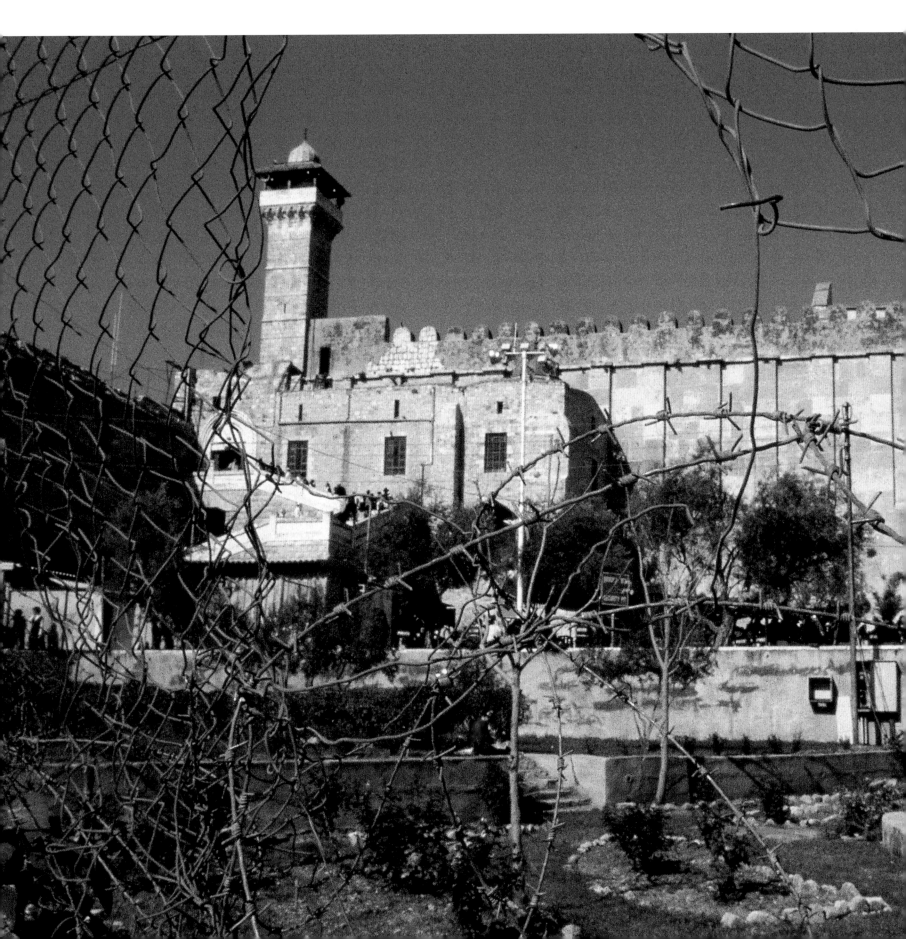

The site in Hebron where Abraham purchases land to bury Sarah, and is later buried himself, is today marked by a shrine called the Tomb of the Patriarchs (*left and top*), which contains monuments to Abraham, Isaac (*above*), and Jacob, along with Sarah and Isaac's wife, Rebekah. The site plays host to an annual Jewish festival (*top*).

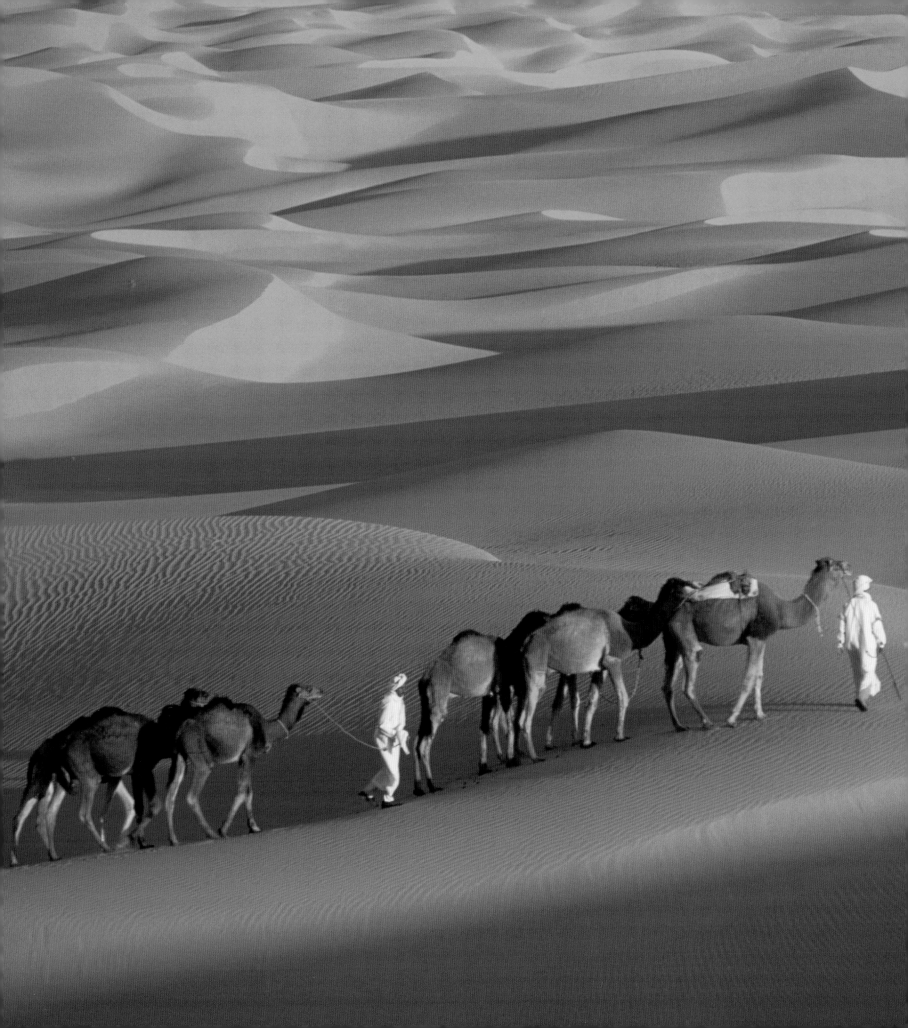

JOSEPH

If the beginning of Genesis is dominated by Mesopotamia, the end is dominated by Egypt. Consistent with the patriarchs' status as pastoral nomads, Abraham, Isaac, and Jacob live largely peripatetic lives, moving from place to place in Mesopotamia, Canaan, and even Egypt. Beginning with Abraham's great-grandson Joseph, however, the biblical story shifts to Egypt, where it remains for the next five hundred years. The story of Joseph, which occupies the last thirteen chapters of Genesis, is a perfect novella, and many consider it the most beautifully written of all biblical stories. The story begins with pain, as Joseph's brothers, envious of his status with their father, sell him to passing caravan traders, who later sell him as a servant in Egypt. Thrust into prison after being falsely accused of attacking his master's wife, Joseph uses his God-given gifts as a dream interpreter to help his fellow inmates and eventually the pharaoh. Joseph's life seems to echo the fortunes of the Israelites. Alone and beleaguered at the start of his life, he passes through hardship in Egypt before rising to become second in command to the most powerful man on earth. The details of his life—the importance of dreams, the images of fat and lean cows, the trappings of authority that are draped on his body—all vividly reflect life along the Nile in the middle of the second millennium B.C.E. If you can't understand the Bible without understanding Mesopotamia, you can't understand it without understanding Egypt, either.

Huge trading routes, on which camel caravans transported goods and people, crisscrossed the Middle East in the second millennium B.C.E.

COAT OF MANY COLORS

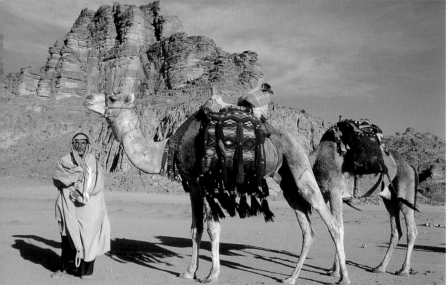

Almost anyone who spends time in the desert is forced to confront in one way or another the tyranny of the camel, the only mammal capable of surviving without water for as much as two weeks in the summer and two months in winter. Camels don't store water in their humps. In fact, camels "store" no extra water at all, drinking only what they require to live. They conserve water by regulating their body temperature (as much as twelve degrees Fahrenheit), thereby eliminating the need to use water to cool themselves down. Humans, by contrast, must maintain a steady body temperature, using perspiration as a coolant.

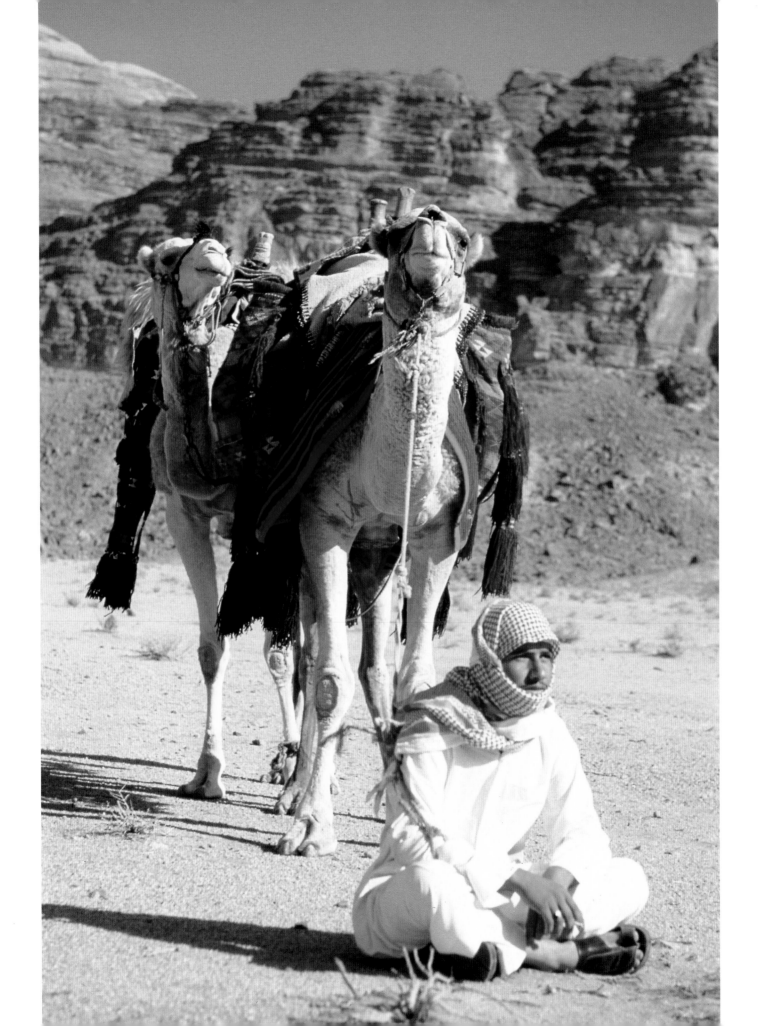

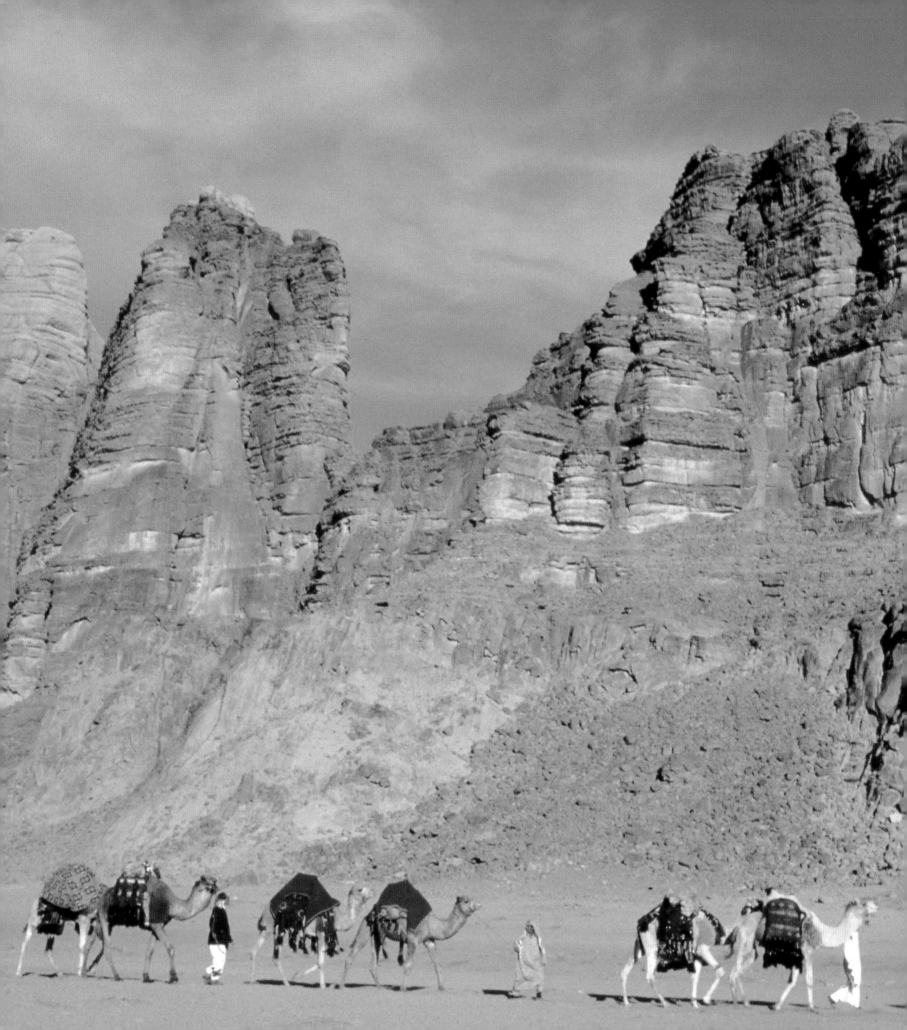

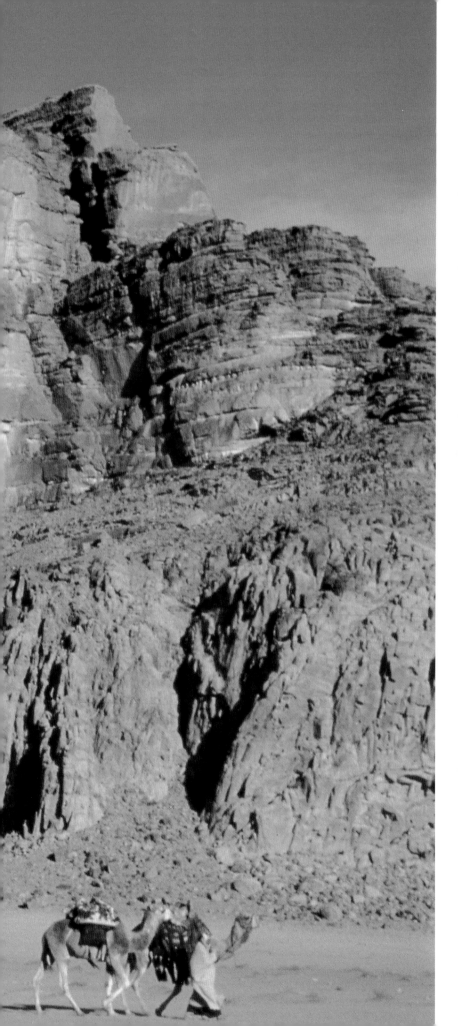

Camels are uniquely suited to desert life. Their humps are filled with as much as eighty pounds of fat, which enables them to live without food for long periods. They have broad feet, which permit them to walk in the sand without sinking, and tight nostrils, which can block blowing sand. In addition, they have extra eyelids, which move from side to side like a windshield wiper to remove sand from their eyeballs. And they have extremely long eyelashes. But camels are also notoriously nasty, the earliest exemplars of road rage. Camels are known to hiss, spit, vomit, shake, and on occasion, go suddenly berserk. A friend of mine once received a postcard from a friend in Egypt. On the front was a picture of a camel; on the back was a single sentence: "Whoa doesn't mean stop to a camel."

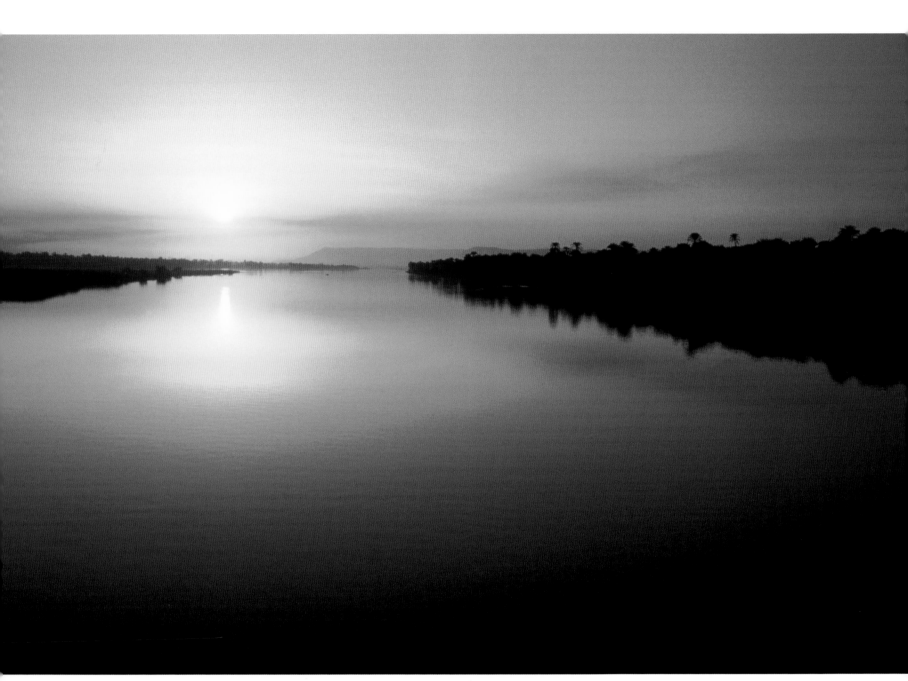

The Nile is to rivers what the Bible is to books. Covering one-sixth of the earth's circumference, the river (*above*) flows 4,180 miles, almost twice as long as the Mississippi, and longer than the Tigris and the Euphrates rivers combined. The key to the river's power was its floods. Nile silt, which flows northward from Ethiopia, is so powerful that until the river was dammed in 1967, the land along its banks (*opposite*) could produce *two* crops a year.

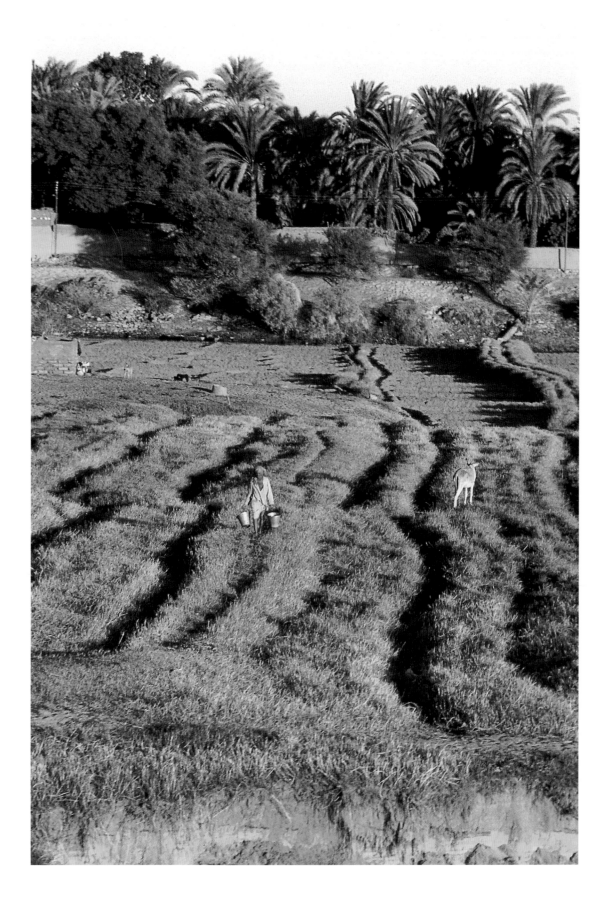

After two years' time, Pharaoh dreamed

that he was standing by the Nile,

when out of the Nile there came up

seven cows, handsome and sturdy,

and they grazed in the reed grass.

GENESIS 41:1–2

The Bible calls the Nile simply *ye'or,* "the River."
Herodotus called Egypt the "gift of the Nile." Napoleon
said Egypt contained "in the Nile, the spirit of the good,
and in the desert, the spirit of evil." But for sheer
intimacy, nothing tops a man I met working on a
riverboat, who told me the river was the most important
thing in his life. "More important than your wife, or
mother?" I asked. He replied, "The river doesn't ask
you for money."

The bounty of the Nile helped produced the wealth of pharaohs, who put their money, in part, into enormous palaces and temples, including Kom Ombo (*below*) and Karnak (*opposite*). One distinctive component of those buildings: They are covered in writing. The hieroglyphics told the stories of Egyptian religion, an act of using writing to build communal identity that was amplified by the Bible.

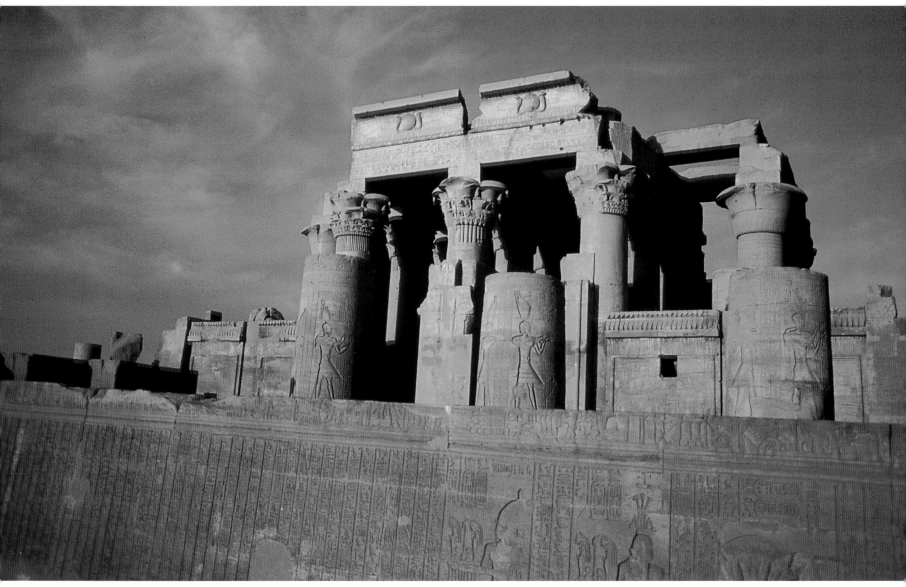

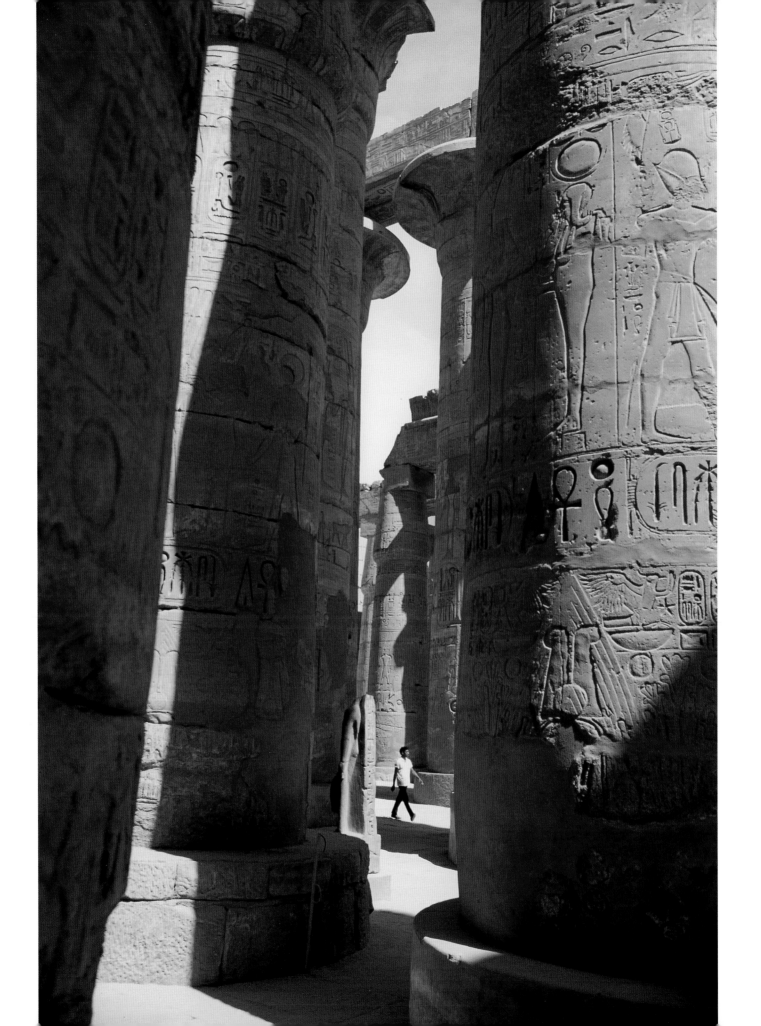

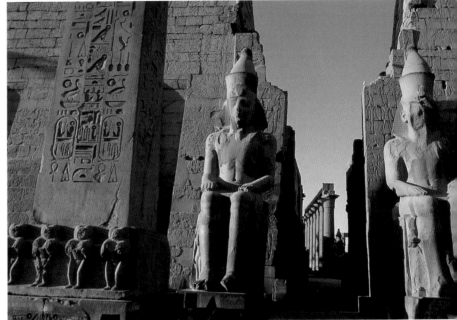

Many scholars agree that the story of Joseph is the best-written story in the Hebrew Bible, a perfect novella in Genesis. Given the importance of writing in ancient Egypt, as evidenced by the walls of Karnak (*above*) and the Luxor Temple (*left*), perhaps the storytelling techniques of the Israelites were enhanced by their exposure to Egyptian life. The deeper they penetrated into pharaonic life, the more enamored they became of the written word.

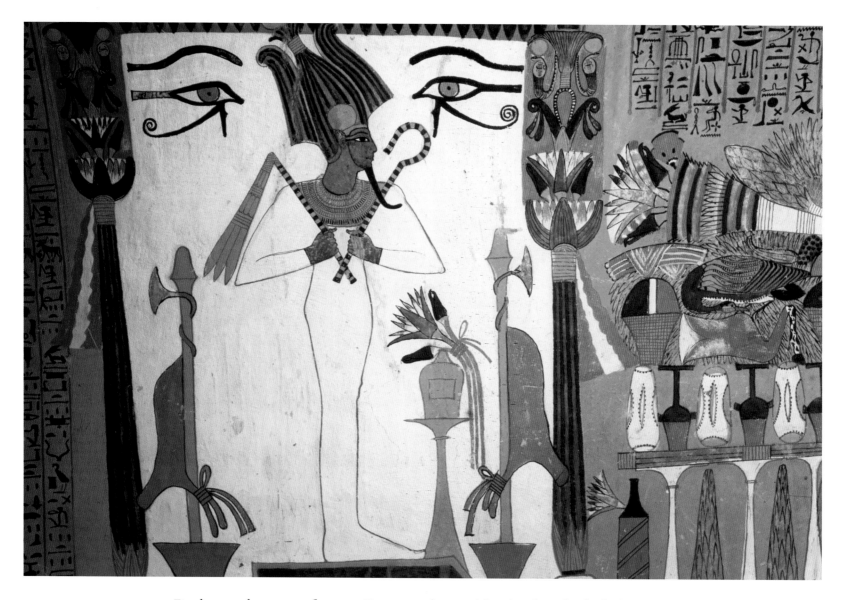

Death was a huge part of ancient Egyptian religion. After the pharaohs died, their souls were believed to survive in order to commune with Amen-Re, the sun god, and Osiris, the god of the underworld. Their tombs, like the one for Seti I (*above and opposite*), are decorated with elaborate paintings describing the pharaoh's journey through the night before rising again at dawn. This fear of darkness would help explain the fascination with prophecy, magic, and life after death. It would also help explain the importance of dreams. Dream-telling was central to the life of the pharaohs, with entire books being written to decipher the images that the kings saw while sleeping. Sure enough, dreams suddenly become significant to the Israelites with the story of Joseph, another indication of the importance of Egypt to the Bible.

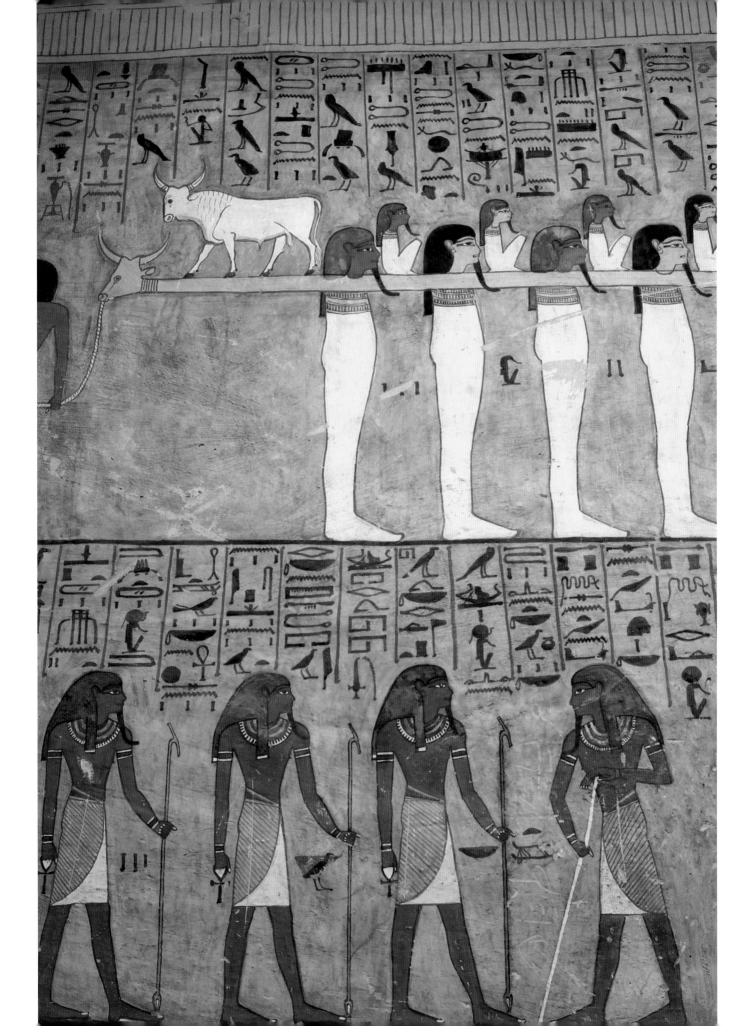

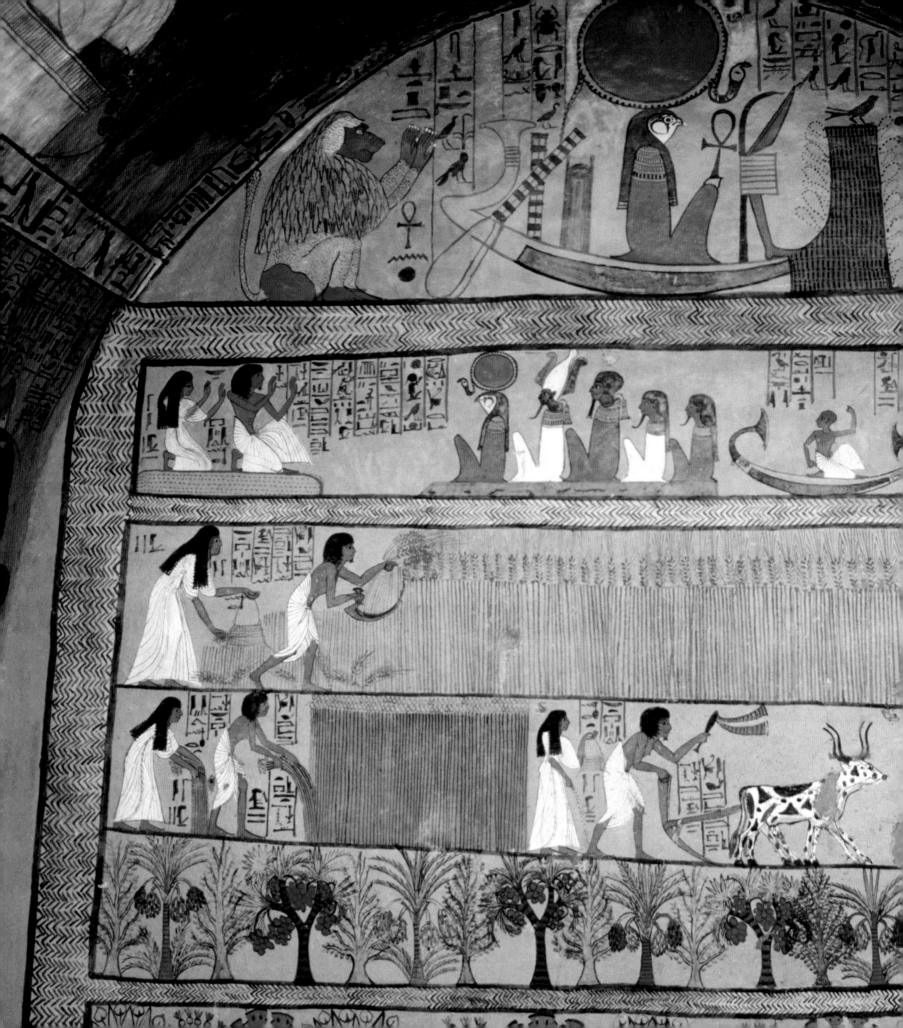

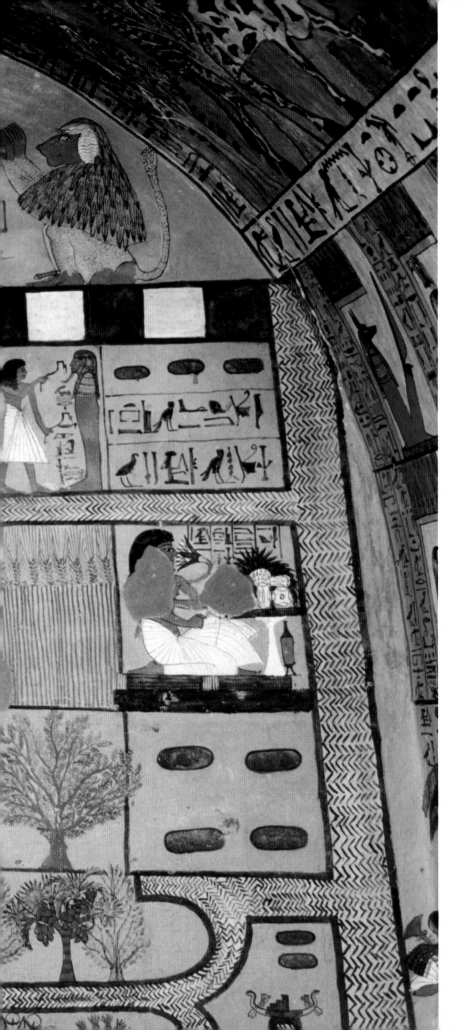

Beckoned to the pharaoh's side from prison, Joseph announces that the seven fat cows indicate years of plenty and the seven lean cows years of famine. The pharaoh is so impressed that he names Joseph his second in command, charged with preserving food for the hardship (*shown in tomb, left*). Foreigners did, on occasion, become prime ministers of Egypt. Also, the swearing-in ceremony, during which Joseph receives the ring and robes, is well-known from art during the mid–second millennium B.C.E. The story clearly conveys deep knowledge of daily life in ancient Egypt.

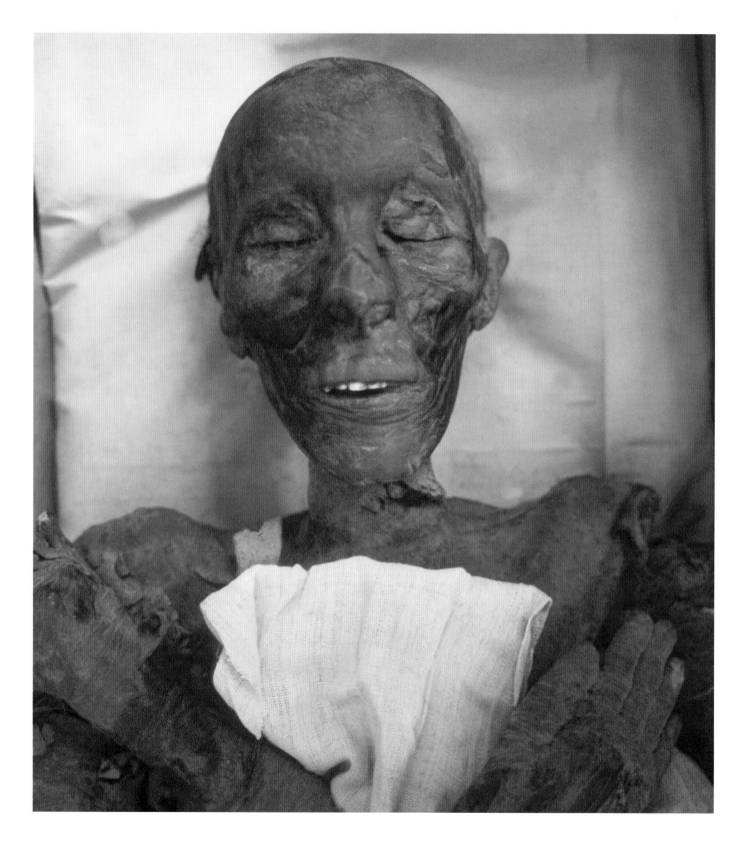

At length, Joseph said to his brothers,

"I am about to die. God will surely take

notice of you and bring you up from this land

to the land which he promised on oath

to Abraham, to Isaac, and to Jacob."

GENESIS 50:24

One mark of how intimately the Israelites were
welcomed into Egypt is that both Joseph and his father,
Jacob, were mummified. Mummification involved
removing the brain through the nostrils, extracting the
organs, then filling the cavity with burnished myrrh.
The cadaver, like those shown opposite and right, was
then soaked in salt—seventy days for the pharaoh, forty
days for noblemen—and wrapped in linen. In the case
of Jacob, the task takes forty days, as it would for a
nobleman, but he is mourned for seventy days, as if he
were a king. With Joseph, the time is not mentioned.

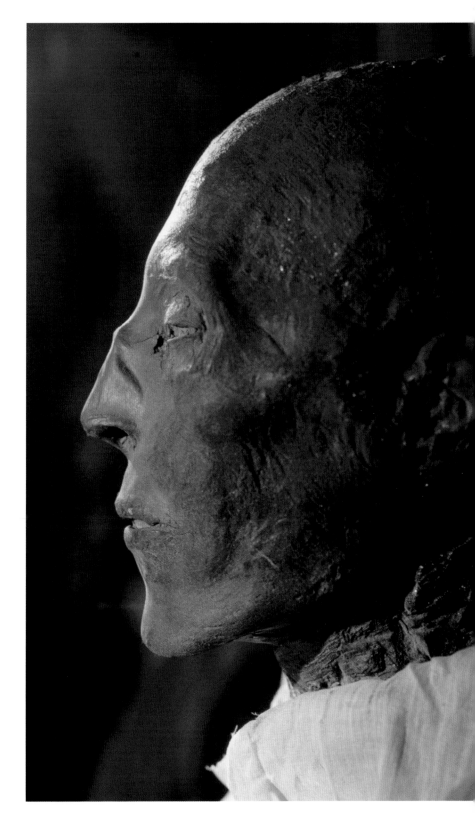

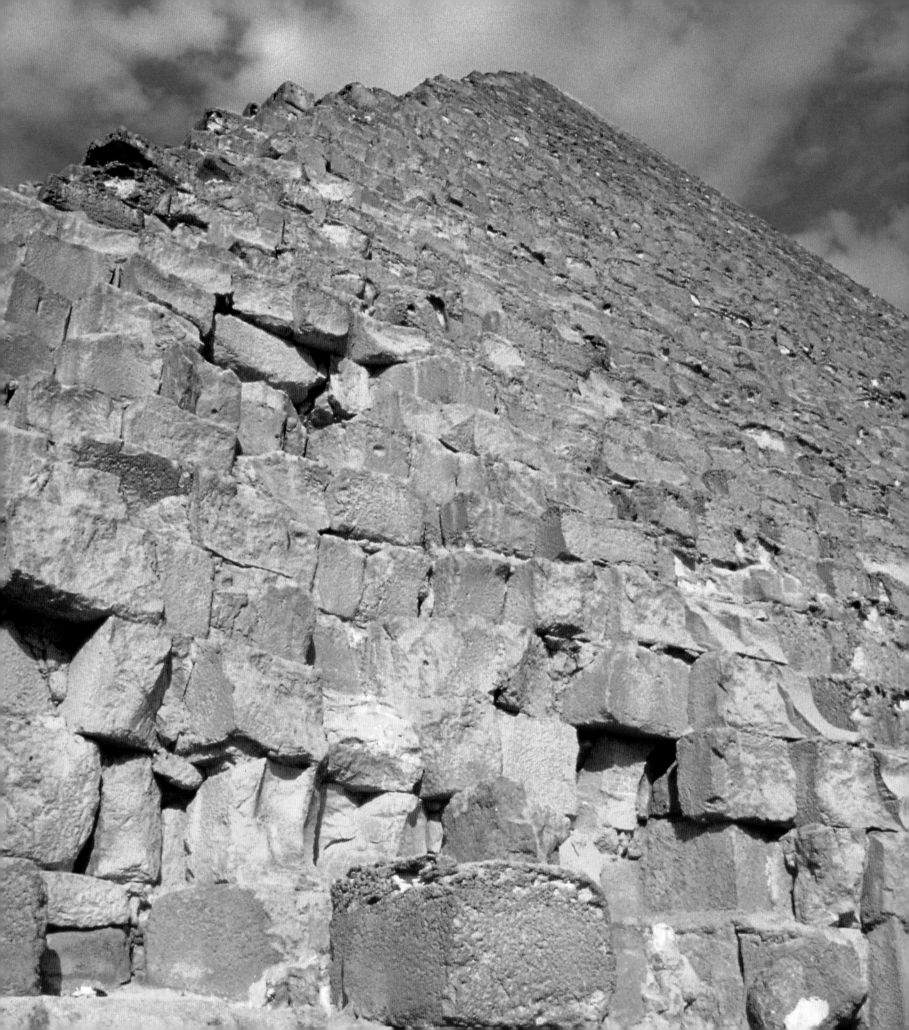

THE EXODUS

The biblical story has a way of starting, stopping, and restarting again. God creates the world, grows frustrated with humans in the Garden of Eden, kicks them out, and starts over. God becomes dispirited with human behavior again, destroys the world with a flood, then starts over with Noah and his family. Another of these periodic new beginnings occurs at the end of the Israelites' enslavement in Egypt with the arrival of the leading figure of the Pentateuch. Genesis includes four major characters—Abraham, Isaac, Jacob, and Joseph—as well as Adam and Eve, and Noah. Moses alone fills the next four books, Exodus, Leviticus, Numbers, and Deuteronomy. He is the central character in the entire Hebrew Bible yet one of the most human heroes ever painted, plagued by self-doubt. Also, introducing a pattern that would become familiar with other prophets—including the Buddha, Jesus, and Mohammed— Moses was born into the civilized world, flees into the desert, has a spiritual experience with God, then returns to share his wisdom with the people he left behind. Finally, more than that of any other figure in the Bible, Moses' personal story is intimately connected to the land. From hearing God's voice in the burning bush, through splitting the Red Sea, to receiving the Ten Commandments on top of Mount Sinai, the epic events of Moses' life are intimately connected to the transforming power of landscape to promote a relationship between humans and the divine.

The pyramids of Giza provide the backdrop
for the showdown between Moses and the pharaoh.

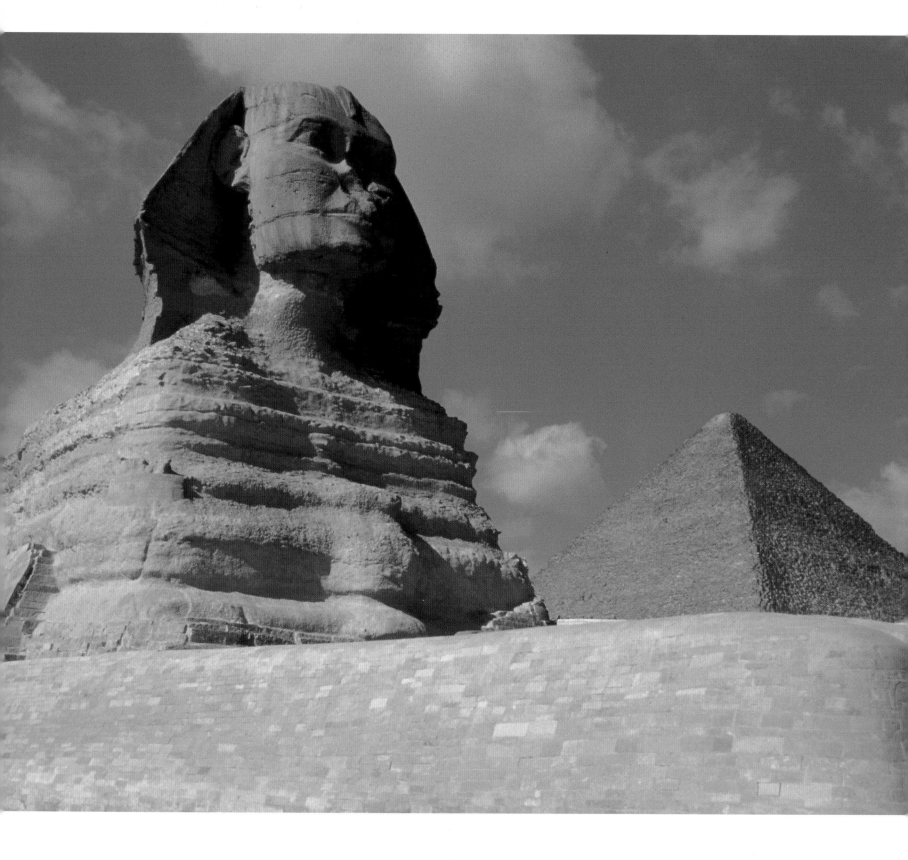

Since antiquity visitors to Giza have suggested that the Israelites built the pyramids. Israeli prime minister Menachem Begin, visiting in 1979, said, "Our forefathers built these." Scholars, though, agree that Abraham was likely born around 2000 B.C.E., which would have Joseph in Egypt around 1700 B.C.E. and the Israelites working for the pharaoh around 1400 B.C.E. The Great Pyramid was begun around 2600 B.C.E.—more than twelve hundred years earlier.

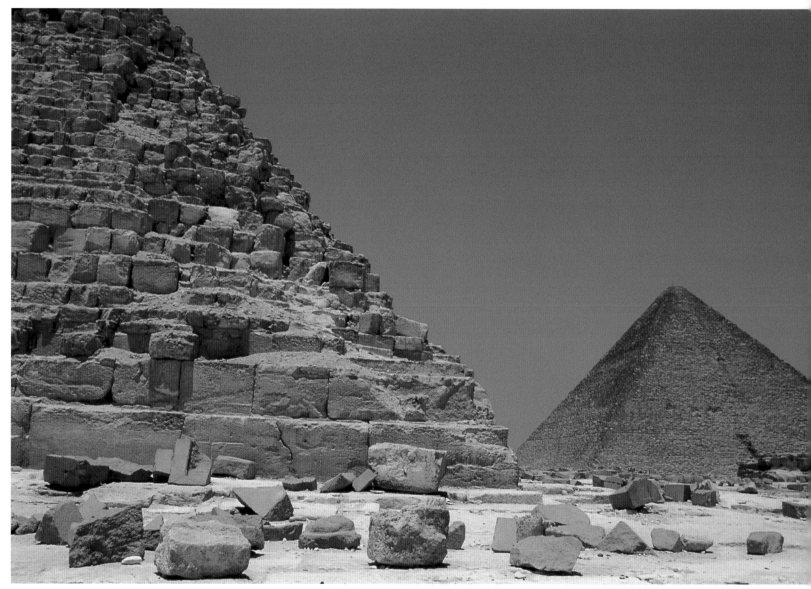

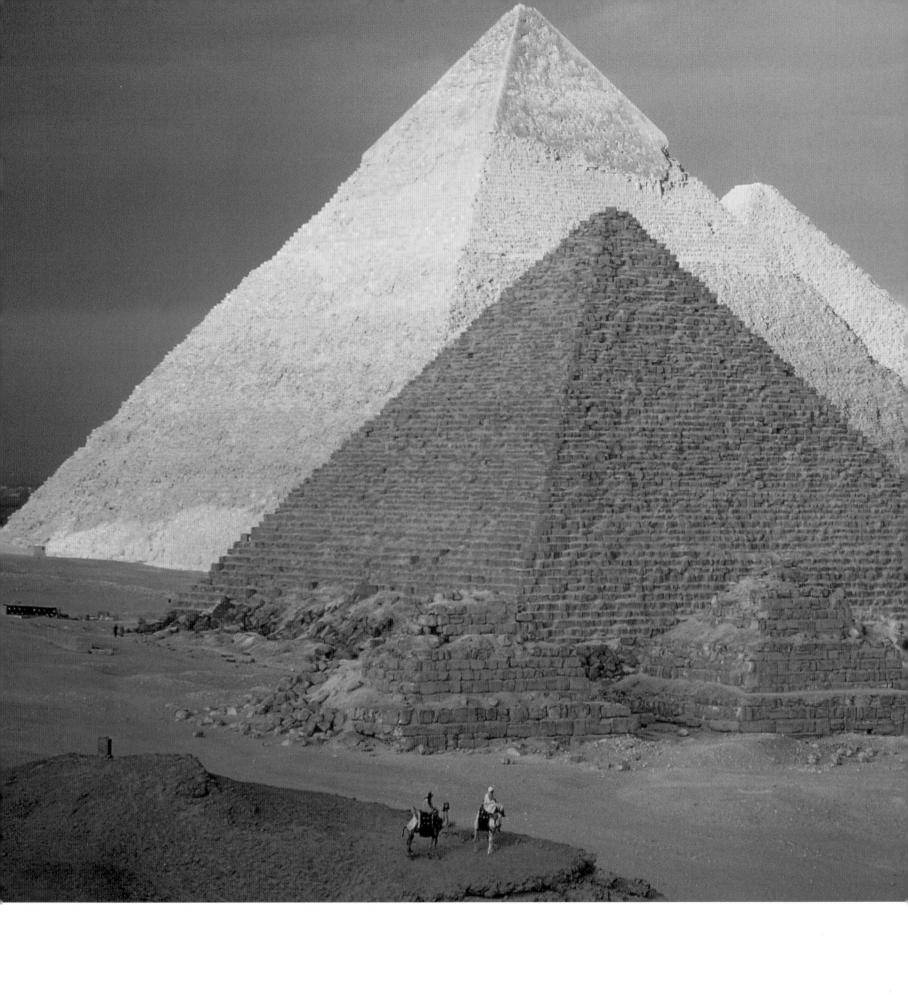

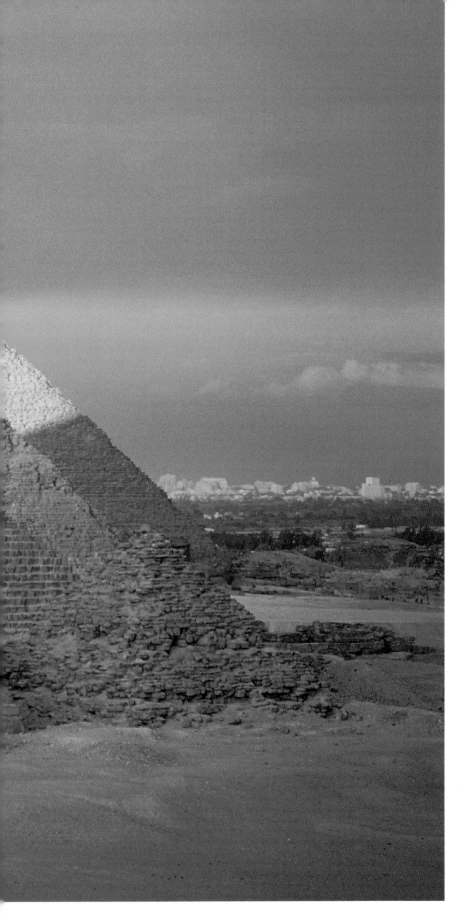

So who *did* build the pyramids? As many as one hundred thousand people, scholars believe, who were hired by the state and organized into teams of ten. Most of the stone was quarried near Cairo, floated across the river during the flood, then dragged up the plateau using levers and rollers. The crews built a ramp of sand to drag the blocks to each level. Moreover, these people were not slaves like those found in the American South; they were peasants recruited by the state to serve the pharaoh, and were housed, clothed, and fed. This feat of organization seems all the more remarkable in that it was unrivaled for centuries. As one proverb goes, "Things dread time; time dreads the pyramids."

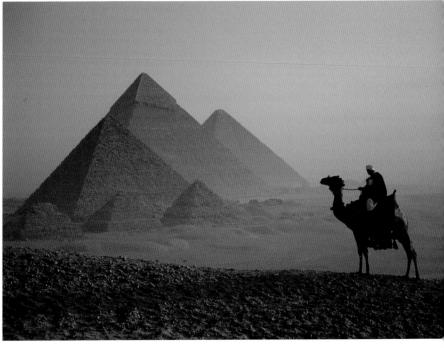

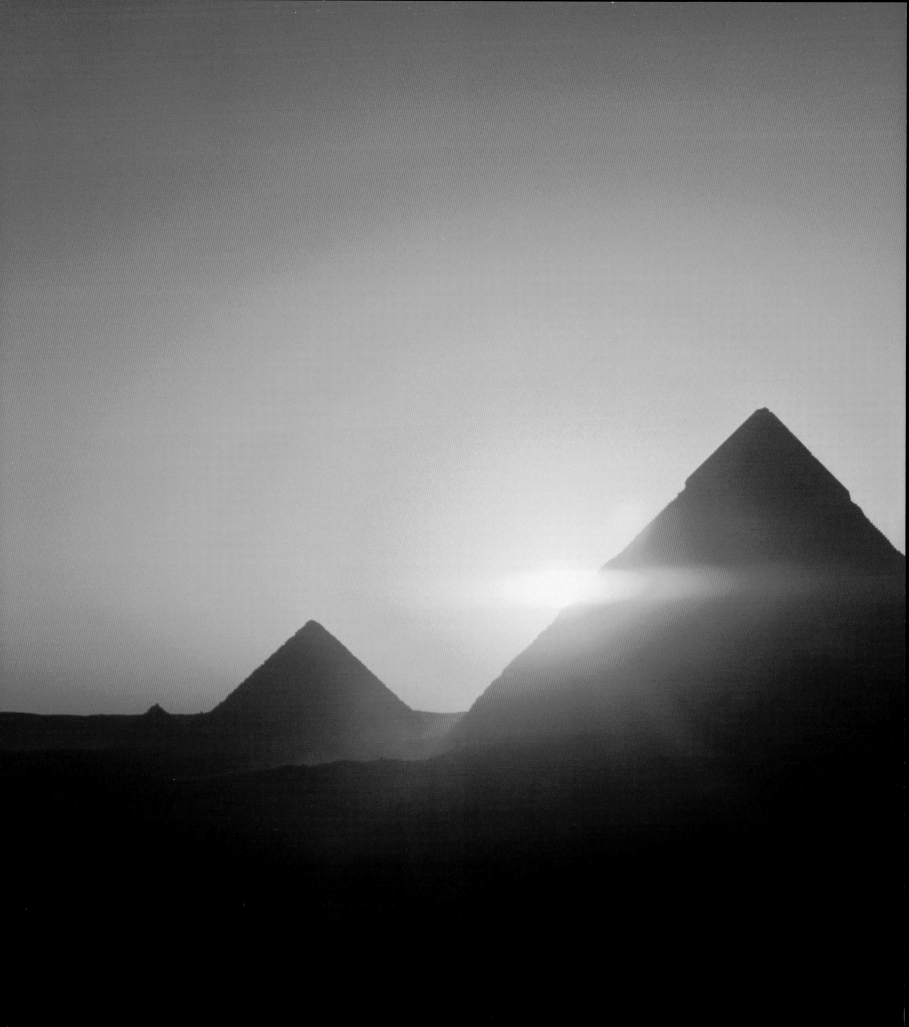

Exodus begins with the advent of a new king of Egypt, "who knew not Joseph." While the old pharaoh encouraged Joseph's family to settle in Goshen, in the fertile delta area northeast of Cairo (*above and opposite*), the new pharaoh fears their descendants are becoming too numerous and orders that all newborn Israelite boys be drowned. One mother tries to hide her son by sticking him in a wicker basket and floating him on the Nile. The daughter of the pharaoh discovers the basket. "This must be a Hebrew child," she says, and names the boy Moses, or Moshe in Hebrew, because "I drew him out of the water." Since the pharaoh's daughter is unlikely to have known Hebrew, her choice for the boy's name probably comes from the Egyptian word *moses,* which means "child," and is also at the root of the names of the pharaohs Thutmose and Rameses.

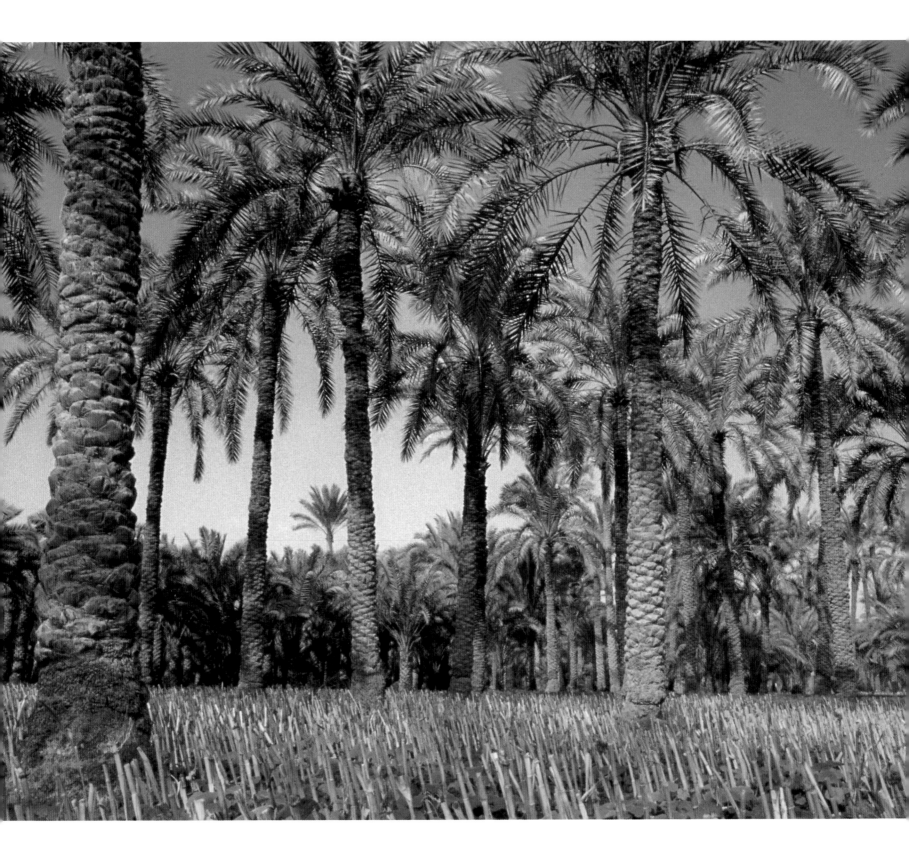

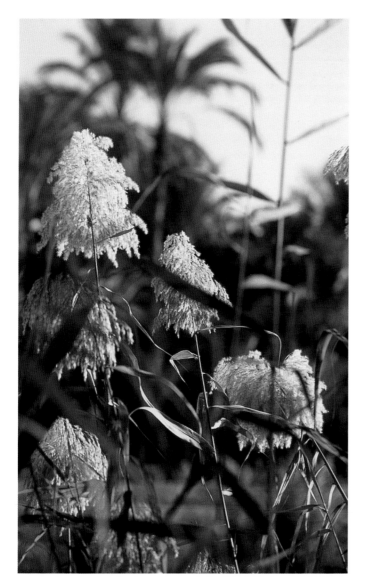

Though raised in the pharaoh's house, Moses still comes to identify with the Israelites. After witnessing an Egyptian beating a Hebrew, he murders the Egyptian and flees the comfort of the delta (*opposite and above*) for the desert, where God speaks to him from a blazing bush. "Moses! Moses!" God says. "Here I am," Moses replies, using the same response Abraham gives to God in Harran. Though Moses is reluctant, God prevails on him to return to Egypt and lead the Israelites to freedom. The epic showdown of the Bible is joined.

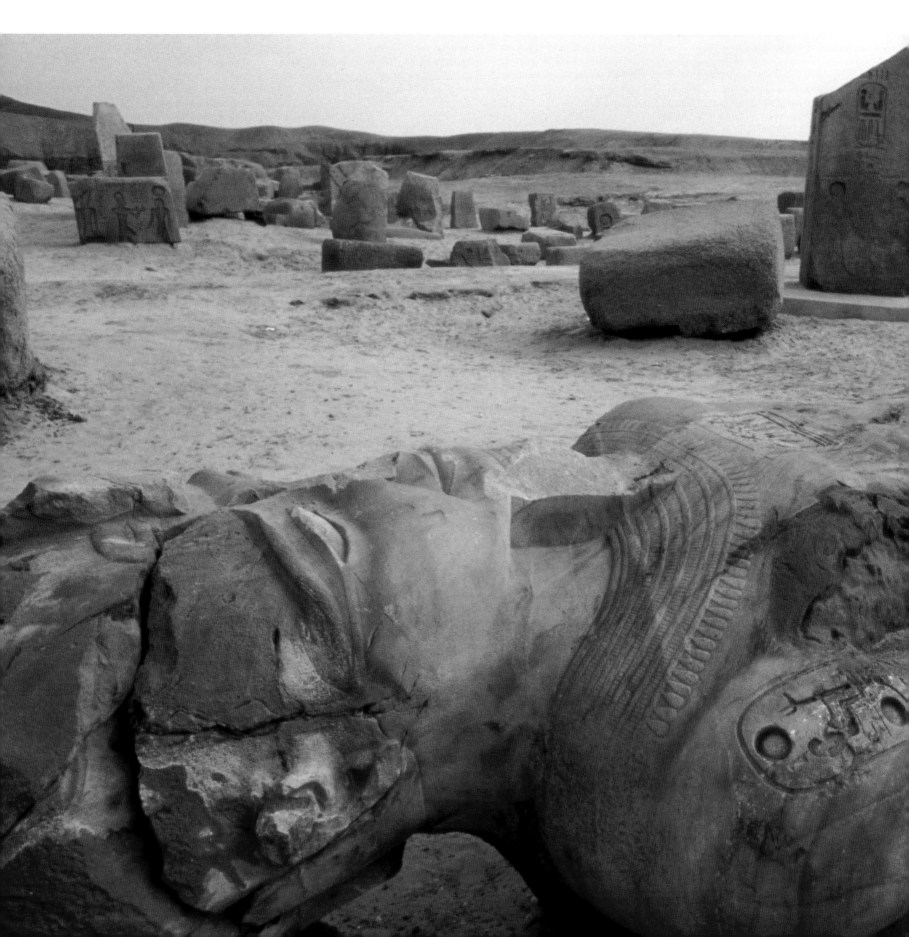

Crossing the Red Sea

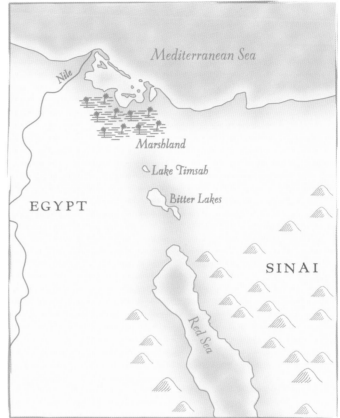

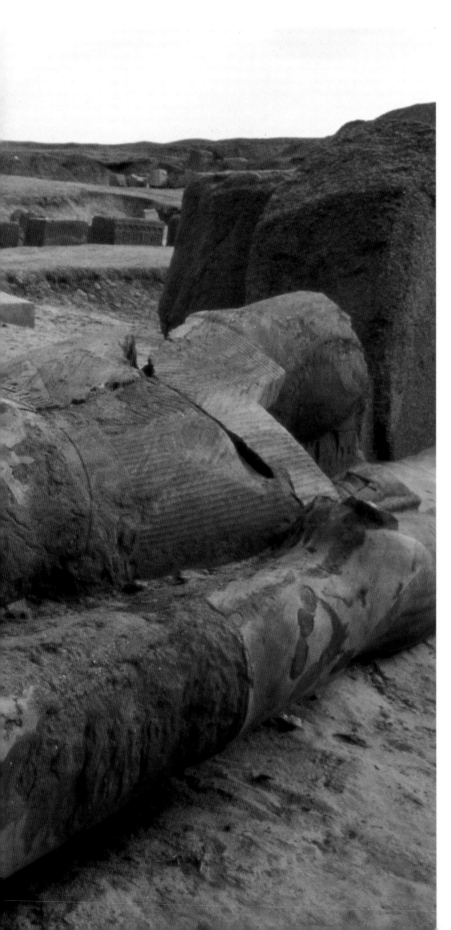

There are five candidates for which body of water
the Israelites crossed when they fled the delta (*left*). The
Mediterranean, the marshes just south of there, the Bitter
Lakes, Lake Timsah, and the Red Sea itself. The biblical
term for this water, *yam suf*, actually means "sea of reeds."
Red Sea is a mistranslation. The reed is papyrus, a
freshwater reed, which would rule out all but the lakes.
Speculation focuses on Lake Timsah, a shallow lake,
and it's easy to imagine, on a windy day, the Israelites
wading across and the chariots getting stuck in the mud.

We talk about the Exodus as being a moment of
excitement—out of slavery, into freedom. But sitting on
Lake Timsah (*above and right*), I began to view the story
differently. The Israelites may have been exhilarated, but
they also must have been deeply afraid, because they
were leaving the most civilized place on earth for the
most barren, based only on the word of a God they'd
never actually seen. On the other side of the Sea of Reeds
was the desert, and the great unknown.

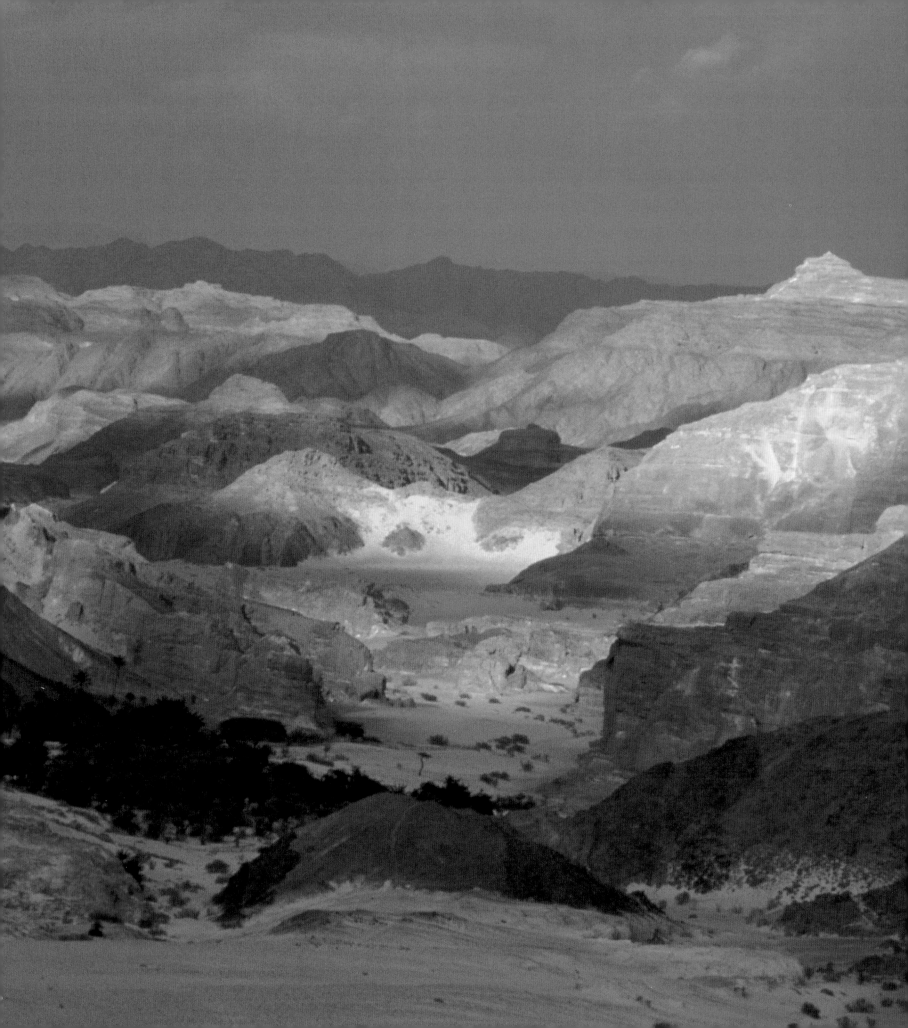

IN THE WILDERNESS

Light. The first thing you notice about the desert is the light. It's a white light, bleached across the horizon, that bounces off the blue of the sky, picks up the glint of quartz in the sand, and washes out everything in its sight. The second thing you notice about the desert is the space. The panorama is almost overwhelming, with sand blowing across the ground, bushes bent against the wind, and everywhere rocks, mesas, dunes, and mountains. Montana may be Big Sky country, but the Sinai is Big Land country. The last thing you notice about the desert is the noise. The first time I went into the desert, I braced myself for the silence. The desert would surely feel isolated. But once I stepped into the open terrain, I was amazed by the din—the wind whining through the mountains, the sand tinkling against my face, the rocks crunching beneath my feet. The desert may be empty, but it's the least quiet place I've ever been. And the most alluring. Every time I leave civilization and burst into the desert, I feel a sense of exhilaration. Because while surviving in the desert can be tense and demanding, it can also be deeply rewarding—especially to the spirit. As the Israelites discovered during their forty years in the wilderness, somehow the act of being in an extreme place opens one up to extreme emotion.

The mountains in the southern Sinai are part of the
Syrian-African Rift, which stretches from the Nile to the Euphrates.

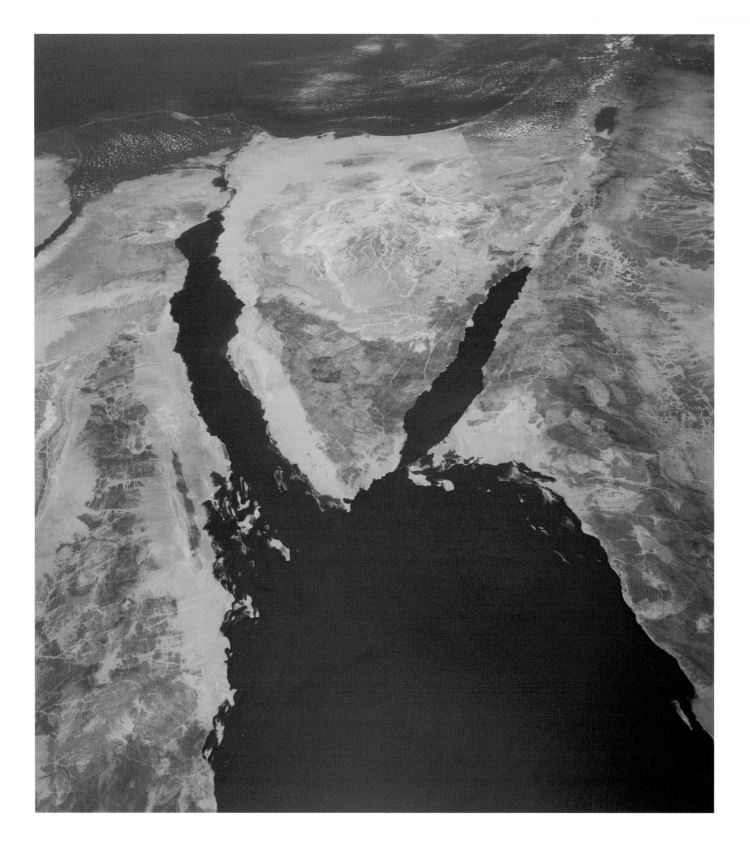

The Sinai has sometimes been referred to as 24,000 square miles of nothing. A giant isosceles triangle wedged between Africa and Asia, it is one of the most barren places on earth. Its unusual terrain has provided endless grist for the question What route did the Israelites take through the desert? There are three possibilities: northern, central, and southern. The most direct would be along the north, but this was the main route of the region and thus heavily guarded by Egyptian troops. Also, there are no mountains and thus no logical place to receive the Ten Commandments. The central route also sounds reasonable. It's on the way to Midian, in southern Jordan today, as the text says Moses was when he returned from the burning bush. And it's closest to Lake Timsah. But it's by far the least hospitable part of the peninsula, with little water and meager mountains. The south has the tallest mountains (*overleaf*) and the most water, but it's not on the way to anywhere and it's quite cold in winter. All in all, the lack of clues in the text means there is no easy answer.

The Exodus

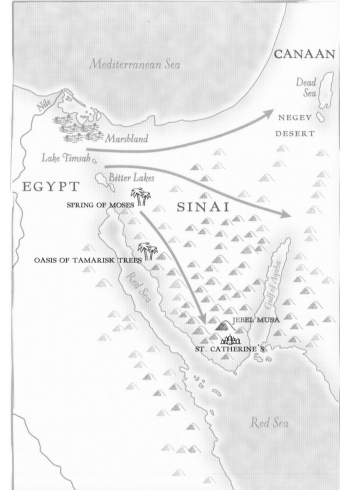

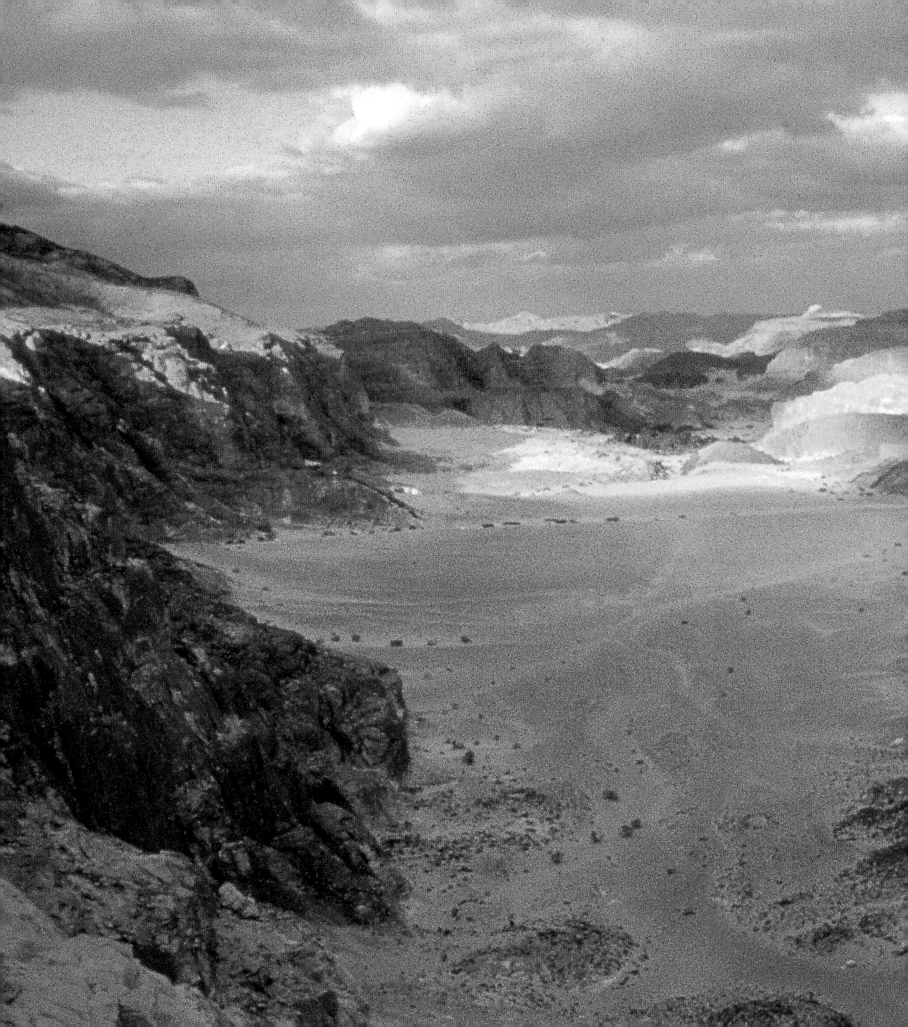

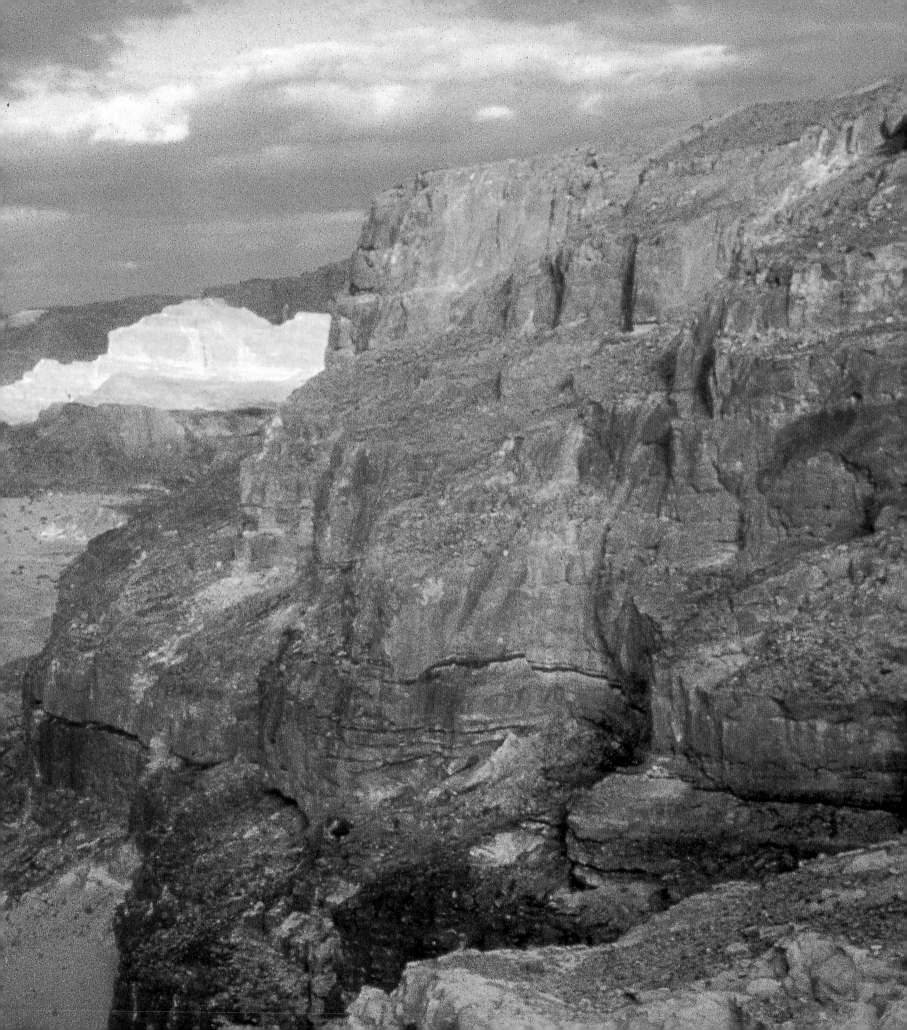

Because of its proximity to places of belief—and conflict—the Sinai has always attracted persecuted prophets. Moses came here, as did Elijah, and later Mary, Joseph, and Jesus. Devout Christian hermits fled here in the early years of the Church, and more recently, when Theodor Herzl first resurrected the idea of a Jewish homeland in the nineteenth century and ran into roadblocks in Jerusalem, he suggested the northern Sinai. Herzl recommended this area because it's close to the Mediterranean and made of classic desert, silken dunes and flat sand that he thought could be cultivated. The farther south one goes, the more the sand turns to hills and then mountains (*following pages*). As the fifteenth-century monk Felix Fabri wrote of the Sinai, "Every day, indeed every hour, you come into a new country, of a different nature, with different conditions of atmosphere and soil, with hills of a different build and color, so that you are amazed at what you see and long for what you see next."

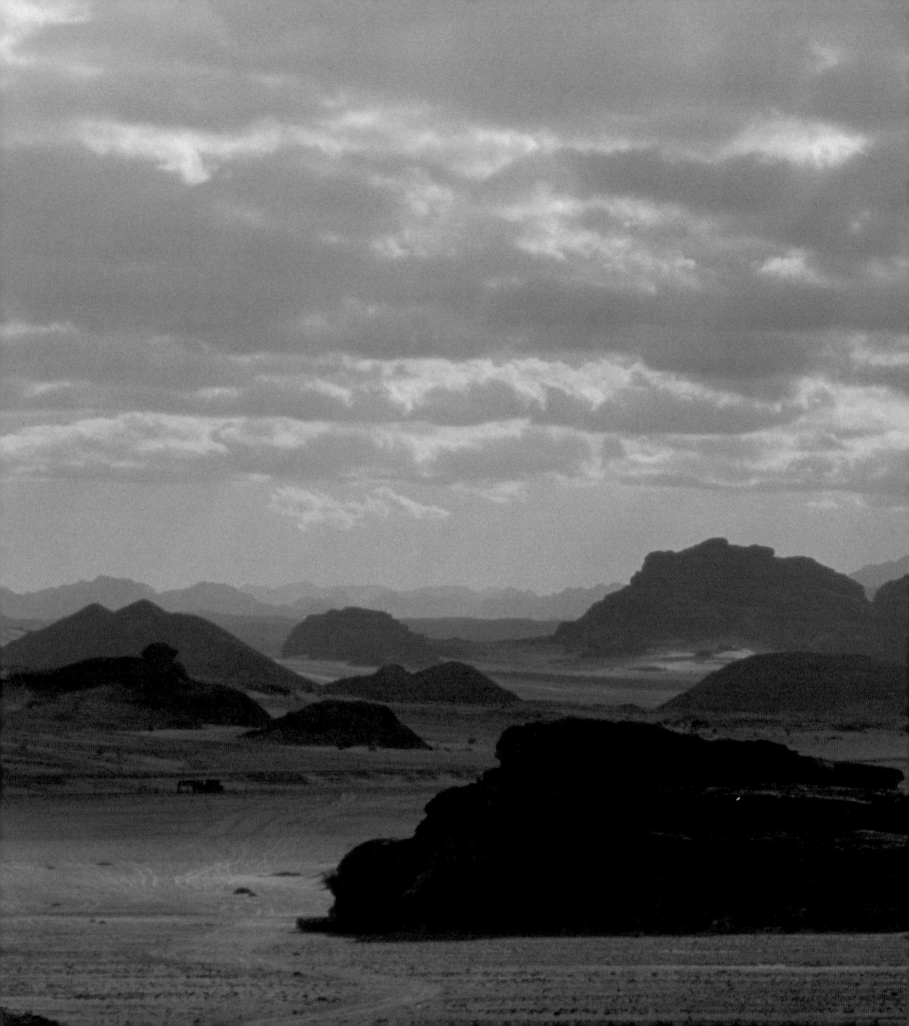

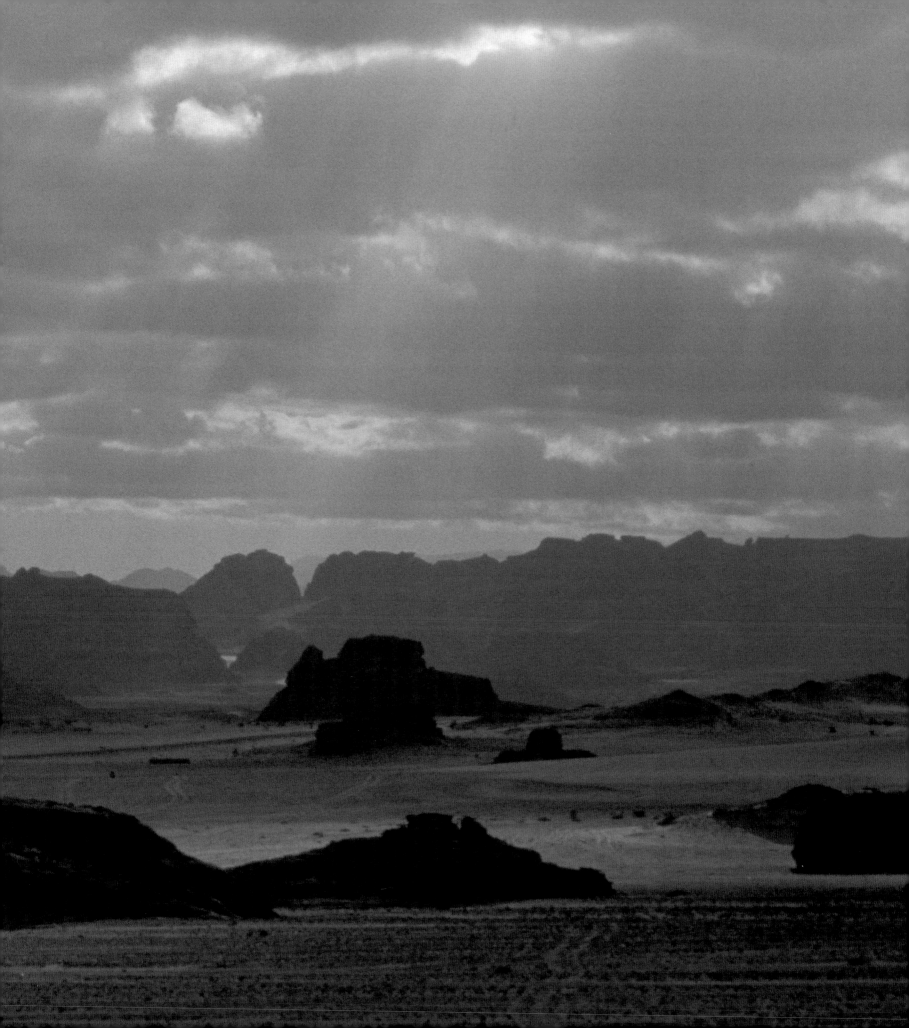

After the Israelites cross the Sea of Reeds, God leads them through the desert, stopping at a number of oases. An oasis is not a miracle, it is a natural phenomenon that draws on subterranean water tables. Most of the water from desert mountains and fleeting rains drains into underground rivers called "wadis." At various places, these underground rivers are squeezed together by mountains or other plates of earth. The effect is sort of like water being poured through the neck of a bottle, whereupon it begins to gurgle and bubble. At the point of narrowing, the water pushes toward the surface, creating an oasis. In the Sinai, palms grow in some oases and local farmers harvest the fronds (*opposite*).

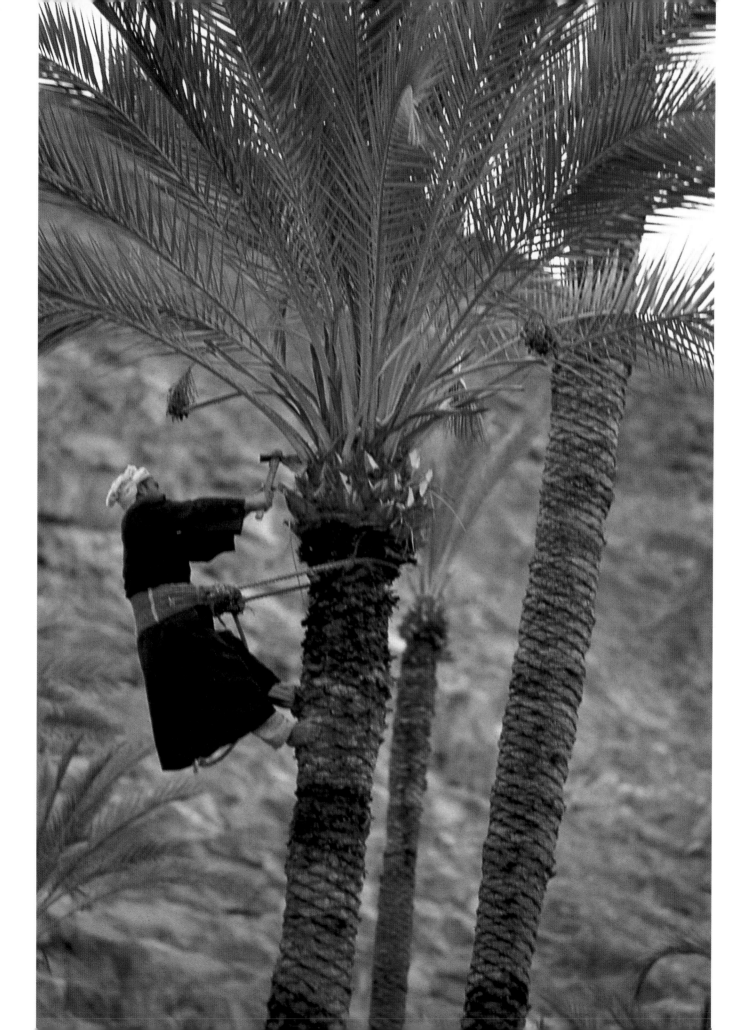

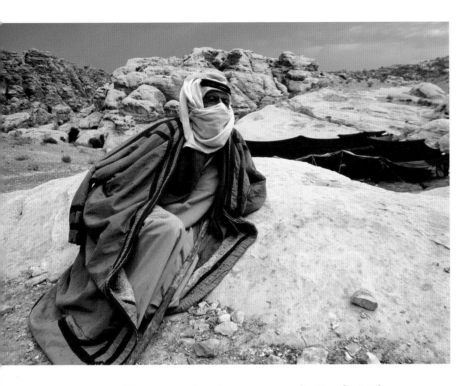

How many Israelites were on the Exodus? The text says six hundred thousand men, which, with women and children, would top two million. The Sinai today has a population of sixty thousand. It stretches the imagination to consider that *two million* people could live with only a handful of oases. Another problem is that two million would represent 20 percent of Egypt at the time. It's hard to imagine that so many people could have left Egypt and *no one wrote it down*. One possible explanation is that the word *elef,* commonly translated as "thousand," might mean "group," meaning six hundred *groups* were on the journey. Another possibility is that the number, like the ages of earlier figures (Noah, nine hundred and fifty years old), has symbolic value.

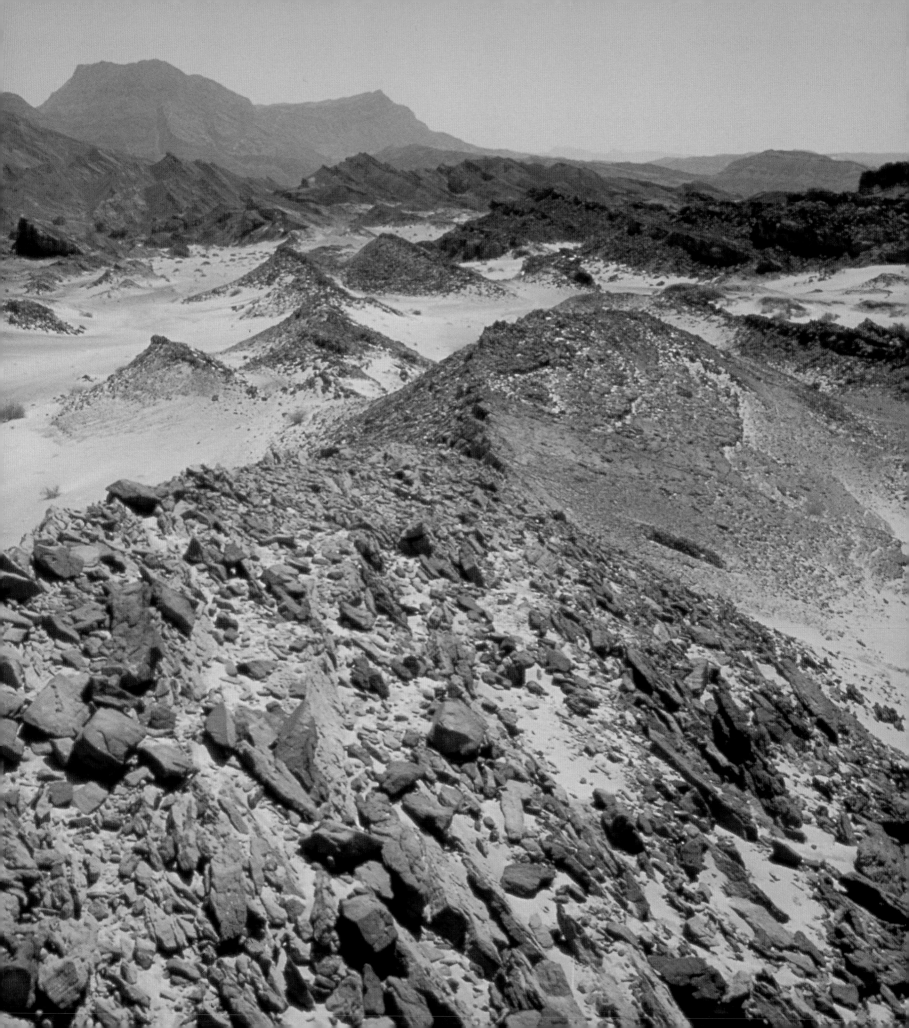

In their second month on the road, the Israelites complain bitterly about their lack of food. God promises to rain down "bread" from the sky every morning and "flesh" every evening. The flesh is quail, and the bread a "fine and flaky substance, as fine as the frost on the ground." The Israelites call it "manna" from the Hebrew expression they mutter when they first see it, *man hu,* "What is it?" Manna is described as being like coriander seed, white, tasting like wafers in honey. But God warns: each person should take only one portion each morning and two on the sixth day. If they don't get the manna before midday, it will melt. The Oasis of the Tamarisks (*left*) may provide a clue for this mysterious food.

A tamarisk is a conifer that grows in various places in the Sinai. In spring, two types of plant lice—*Tabutina mannipara E.* and *Najacoccus seprentinus*—infest the salty bark, suck the sap, and excrete a white, sweet, sticky substance that forms into globules (*opposite and below*) and falls to the ground. If you pick up these globules before midday you can eat them; by noon, they have melted. The bedouin in the area call them "manna," and scholars estimate about five hundred pounds are harvested each year. Once again, reading the biblical narrative with my archaeologist companion Avner Goren (*right*), I was struck by how the story shows intimate knowledge of the biology of the region.

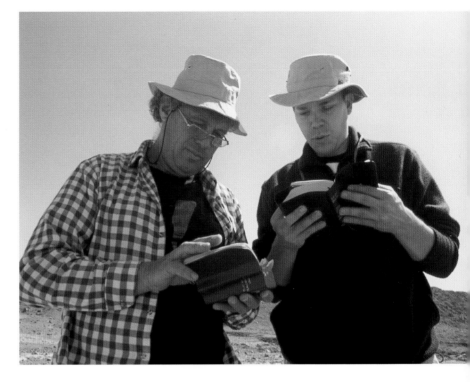

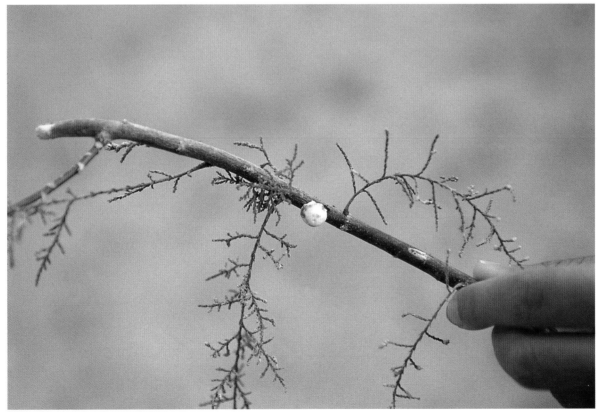

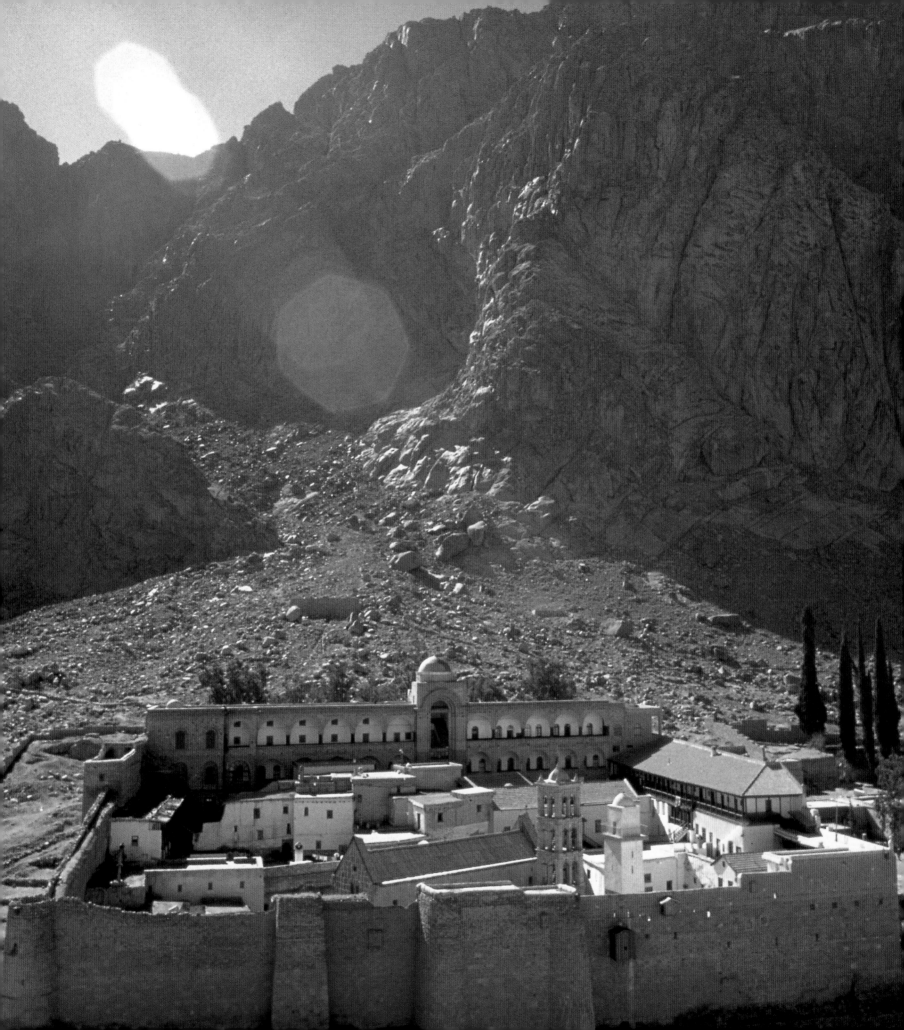

THE TEN COMMANDMENTS

The sacred relationship among the people, the land, and God— forged with Abraham—reaches its climax in the Five Books of Moses with the delivery of the Ten Commandments. After the Exodus, God could have led the Israelites directly to the Promised Land; instead he led them into the wilderness. Reminding humans of their neediness seems central to his message. Once they were in the desert, he could have given them his laws anywhere; he chose Mount Sinai. The significance of this location cannot be overstated. The Israelites, who for centuries were enslaved in the flatlands of Egypt, had not encountered mountains as high as the Sinai for at least six hundred years. The Bible says they "trembled," and seeing the red granite mountains in the southern Sinai, one of the leading possibilities for the site, one can understand why. But then God goes even further. He covers the mountain with clouds, summons Moses to the summit, and descends in a thunderous cloud of fire and smoke. At the climactic moment of the story, when God gives his laws that will govern humanity for all time, he chooses to come down *to the land itself*. He seems to be saying, with his very action, that a primary site to encounter the divine is in a place of personal vulnerability, exposed to extreme conditions, surrounded by a community of wanderers, open to the promise of a better, more moral world.

Saint Catherine's monastery at the base of
Jebel Musa, or Mount Moses, in the southern Sinai.

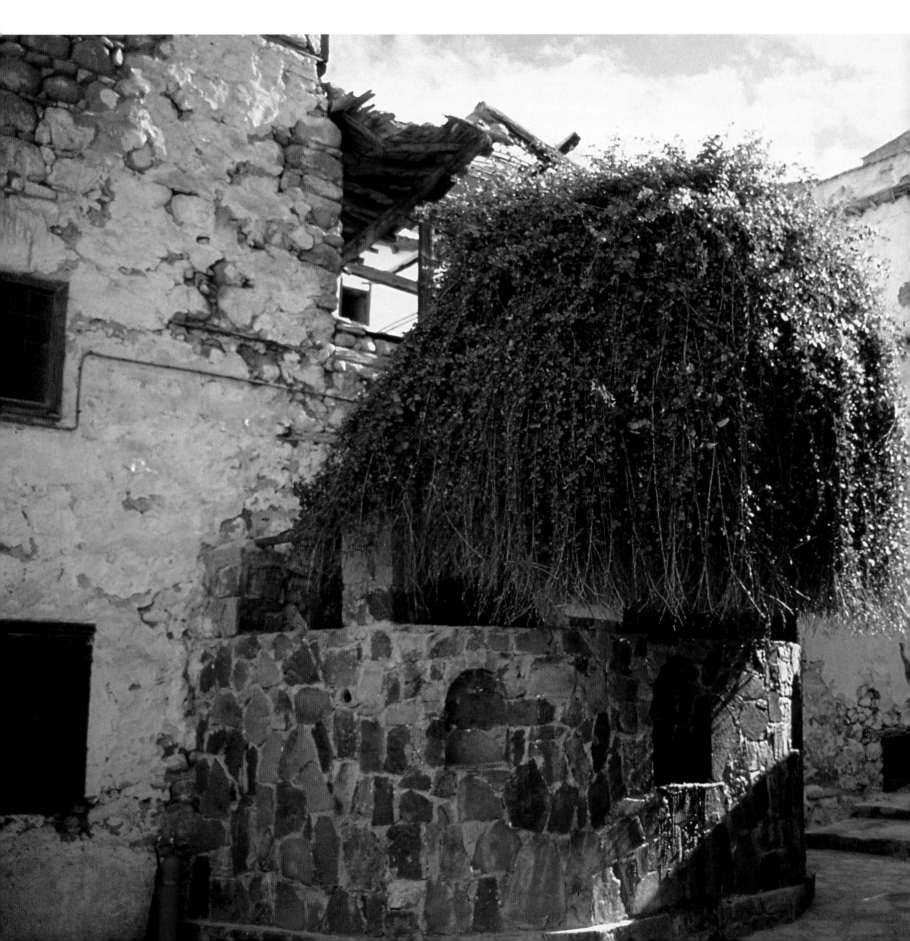

Saint Catherine's monastery, named after a martyred Egyptian saint, was founded in the fourth century C.E. on the basis of a tradition that said the burning bush was located at the bottom of the area's second-tallest mountain, Jebel Musa, or Mount Moses. The monastery contains an enormous fountaining shrub (*left*), about six feet tall, with dangling branches like a weeping willow. A fire extinguisher sits off to one side. The first time I visited, I thought the device was an eyesore, but then I realized the unintended humor. Was this in case the burning bush caught fire? Monks claim the plant is unique and has been growing in the same spot since the time of Moses. Few scholars these days engage in pinpointing natural phenomena from the text, but clues suggest the bush is rare. It belongs to the seldom seen species *Rubus sanctus*, a wild raspberry that grows primarily in the mountains of Central Asia. Only a few specimens have been found in the Middle East.

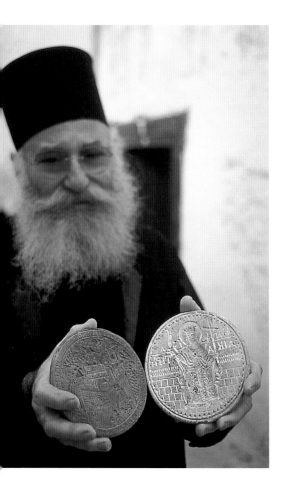
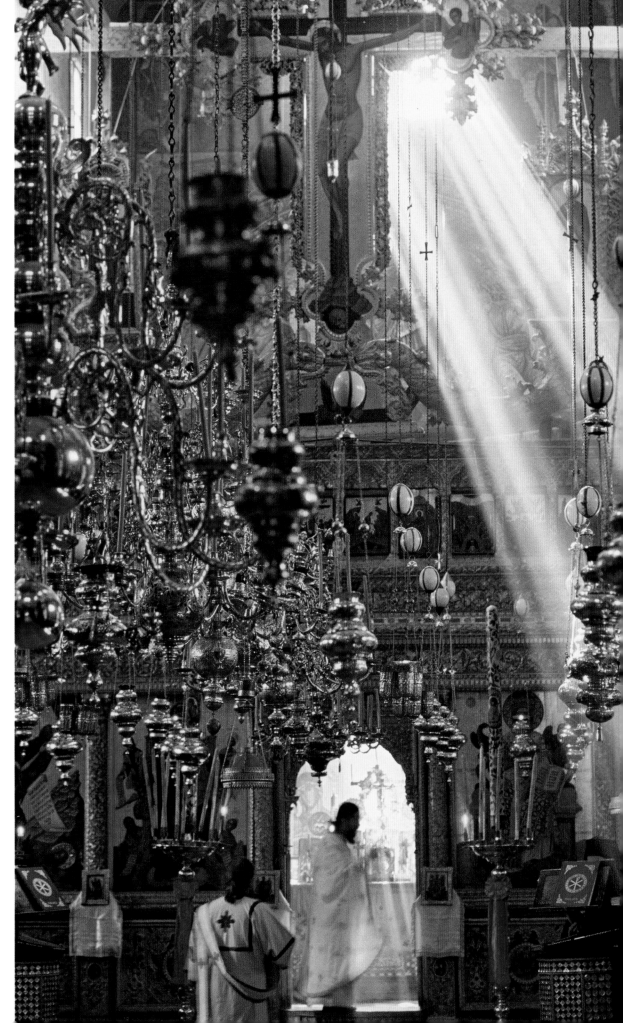

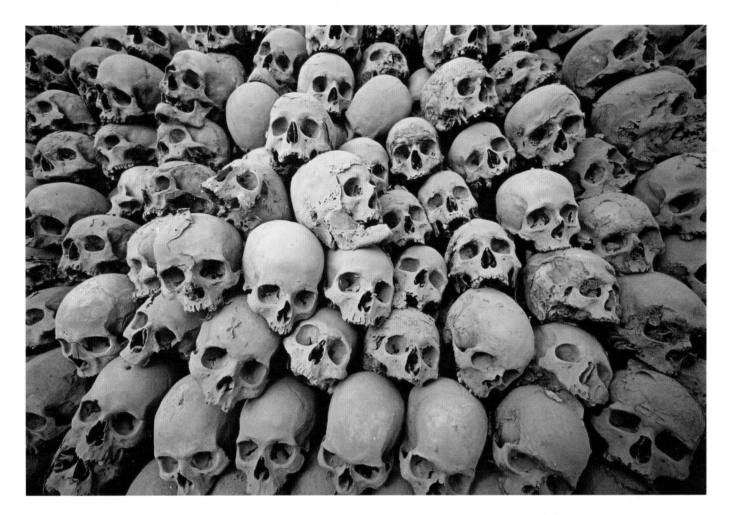

Christened in the fourth century C.E. by Empress Helena, the Monastery of the Burning Bush didn't thrive until 1000 C.E., when it became associated with Saint Catherine. Born in Alexandria in the late third century C.E., Catherine (née Dorothea) met and mystically married Christ and was martyred for her beliefs. Her remains were secretly deposited on a mountain in the Sinai. Monks claim the monastery's basilica (*opposite*), built between 542 and 551 C.E., is the oldest continually operating church, and its doors are the world's oldest. Services are still held five times a day in Byzantine Greek. About two dozen monks, including Greek-born Father Janis (*opposite left, holding bread molds with the image of Saint Catherine*), live in the monastery today. Just outside the walls, a crypt (*above*) contains the bones of every monk who ever lived here.

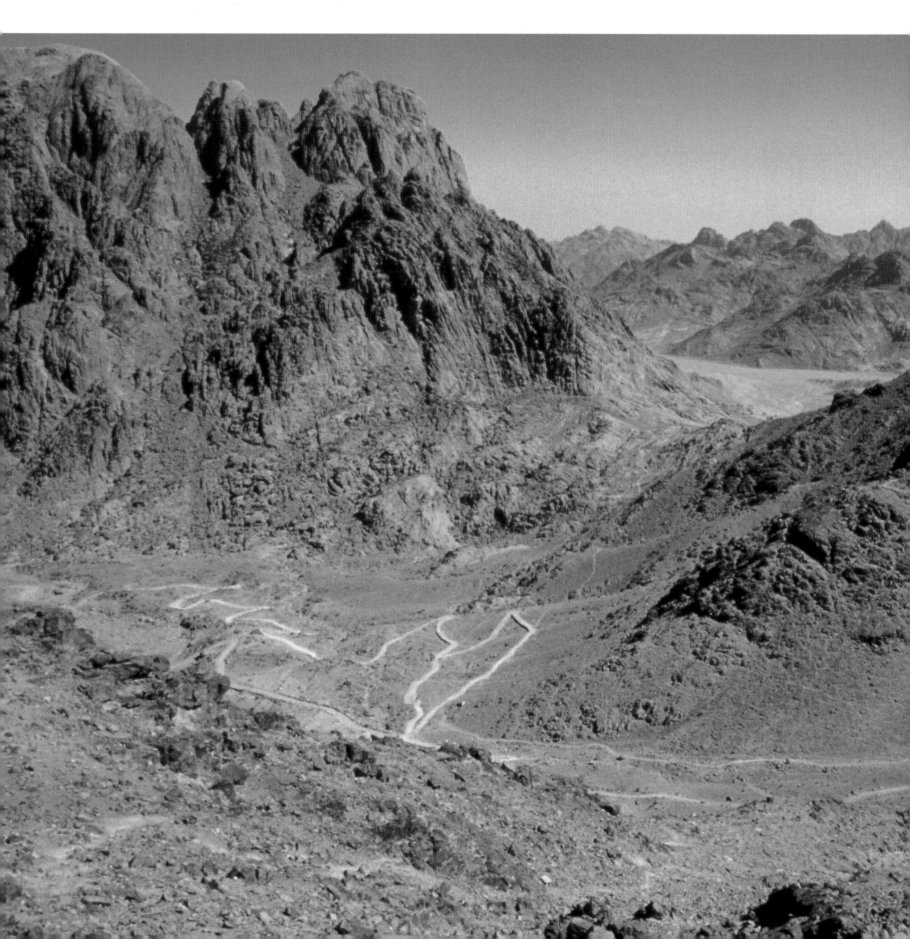

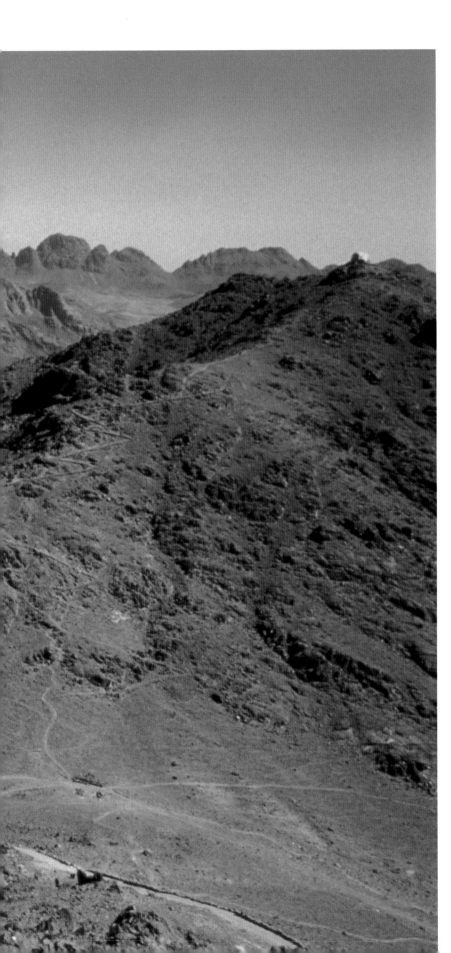

At 7,455 feet, Jebel Musa (*left and in the background above*) is not a particularly tall mountain, but its barren face is dramatic. A mixture of red and gray granite, Mount Moses rises straight from the ground and softens slightly at the top like a drip castle. As the American visitor John Lloyd Stephens wrote in 1836, "Among all the stupendous works of Nature, not a place can be selected more fitting for the exhibition of Almighty power."

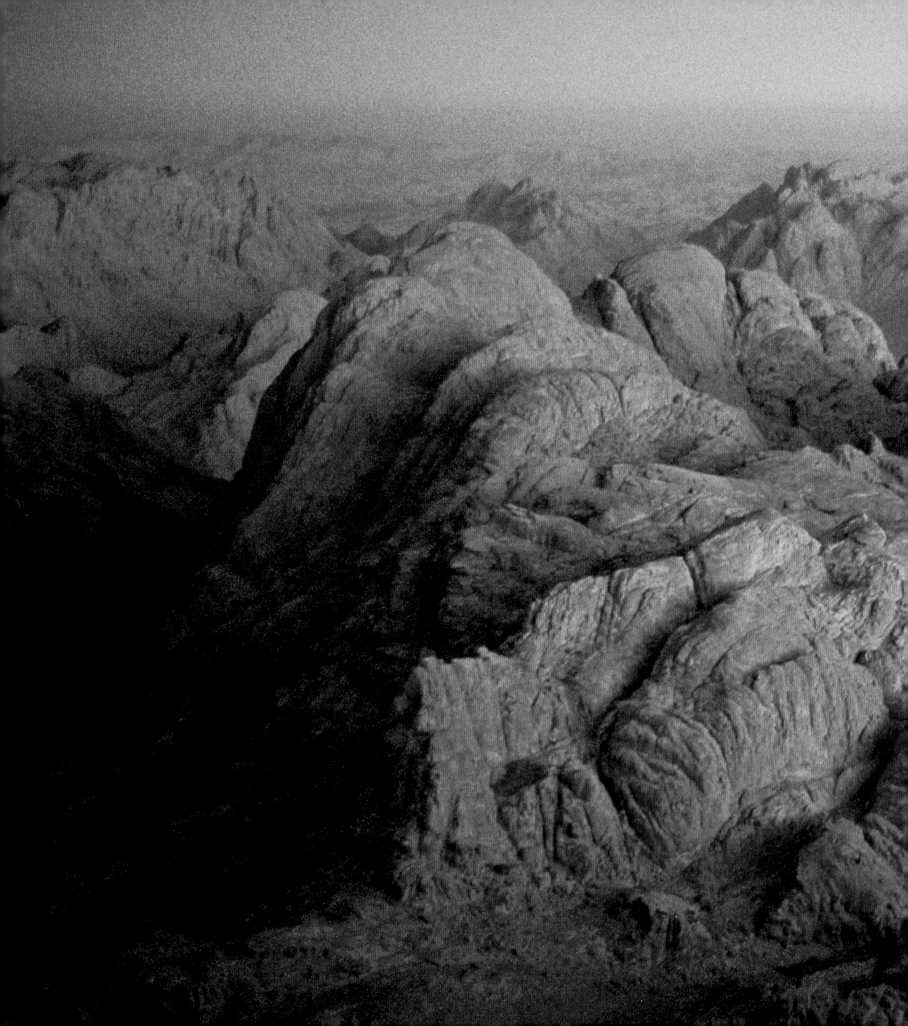

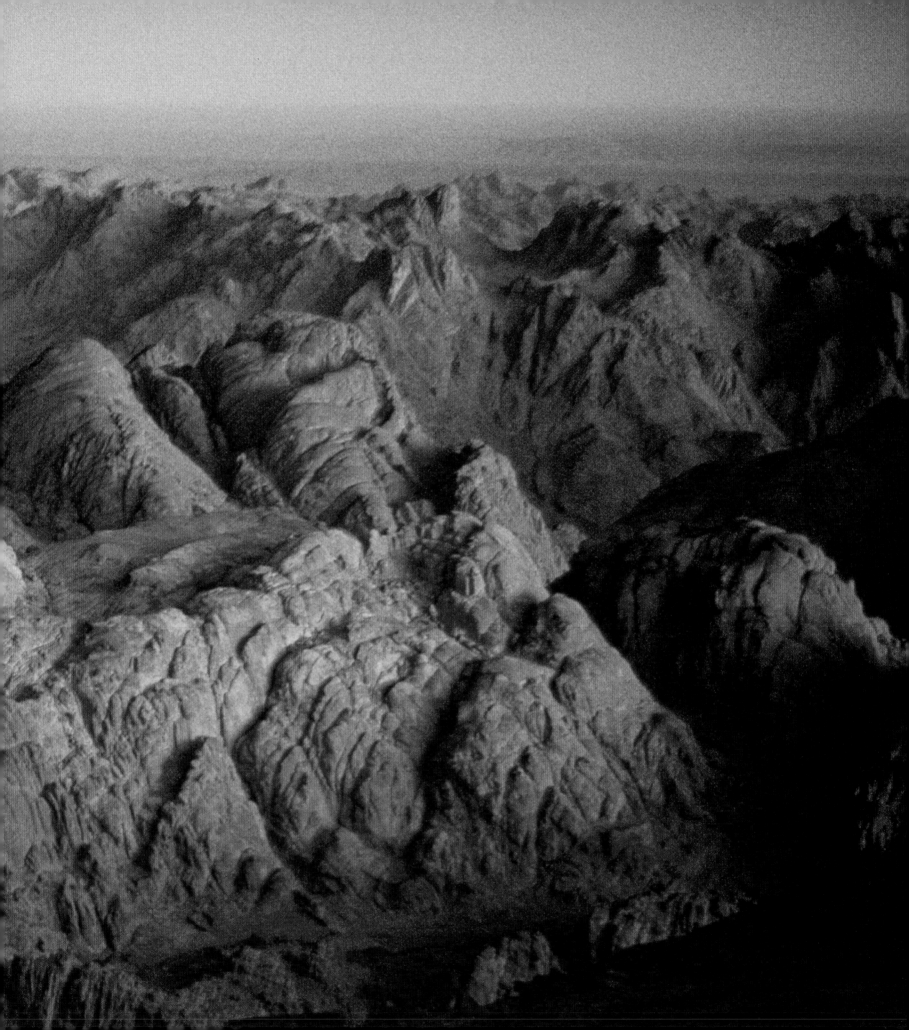

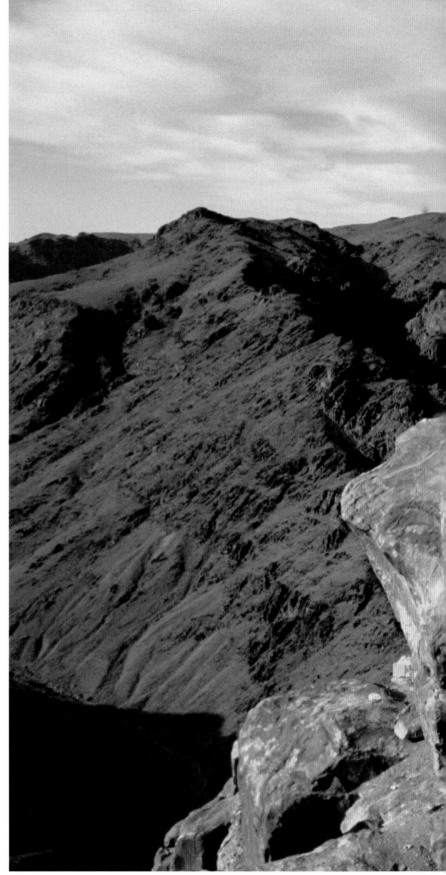

The summit of Mount Moses contains a chapel (*above and right*), a mosque, and a bedouin rest tent, all in a space less than one hundred feet long and thirty feet wide. The church, dedicated to the Holy Trinity, was built in the 1930s on a spot that has been almost continually occupied since the fourth century. Monks claim the rock beneath the church floor contains the imprint from Moses' knees where he bowed down to God. The buildings, though, are overshadowed by the view, a 360-degree panorama of blood-colored mountains (*overleaf*).

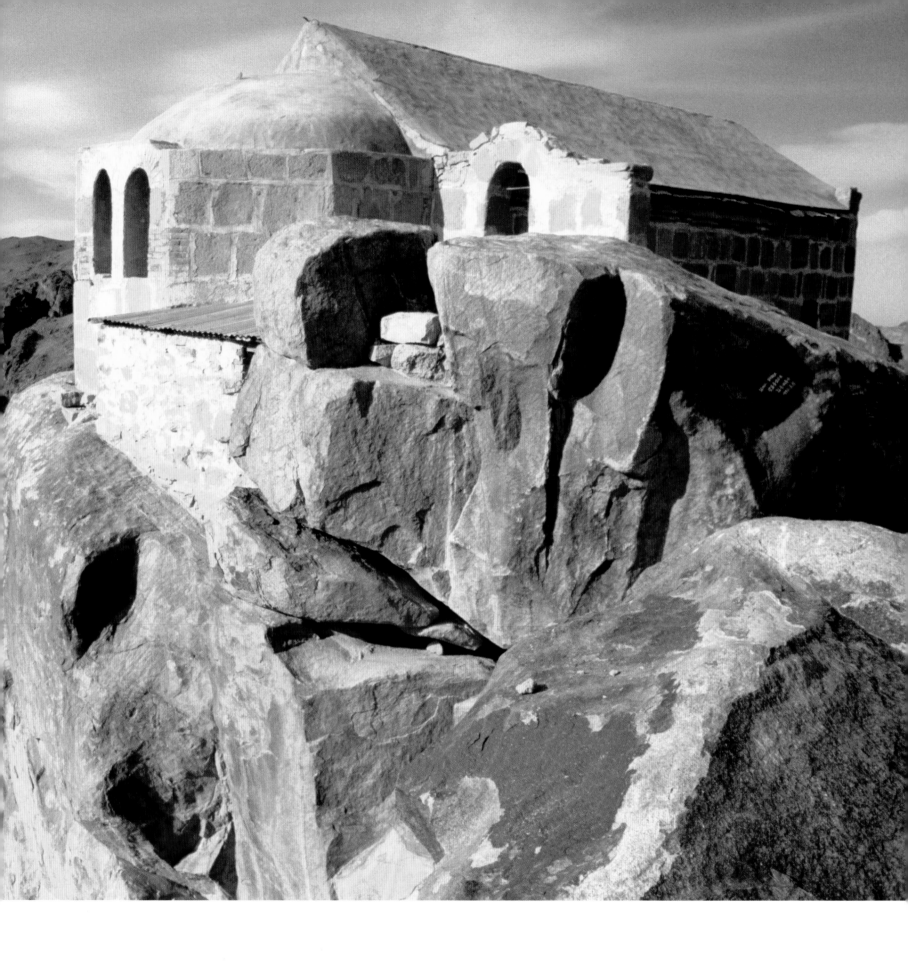

TOWARD THE PROMISED LAND

First, you get thirsty. You wake up thinking about water. You go to bed thinking about water. You dream of water. You wonder, "Am I drinking enough water?" Two liters a day. Or is that three? Just drink. Because "*If you're thirsty, it's too late.*" Next, you get hungry. And you stay hungry. Your first few days in the desert, you have remnants of the city, a bit of cookie, an apple. You've outwitted the desert. But then the desert wins. You're left to the ground, which is a cruel resort. Food, like water, becomes a symbol of salvation. Finally, you get tired. You get tired of the heat, of the cold. But mostly you get tired of the sand. Sand is relentless. It goes through your shoes, through your socks, and lodges in between your toes. It infiltrates your food, sticks onto your teeth, and passes into your stomach. Spend enough time in the desert, and you begin to see that nothing is quite what it seems to be. Everything becomes grist for God. As Moses tells the Israelites near the end of their journey: "Remember the long way that the Lord your God has made you travel in the wilderness these past forty years, that he might test you by hardships to learn what was in your hearts." By its sheer demands, the desert asks a simple question: "What is in your heart?" Or, put another way, "In what do you believe?"

Only sixty thousand people live in the barrenness of
the Sinai, an area the size of Ireland.

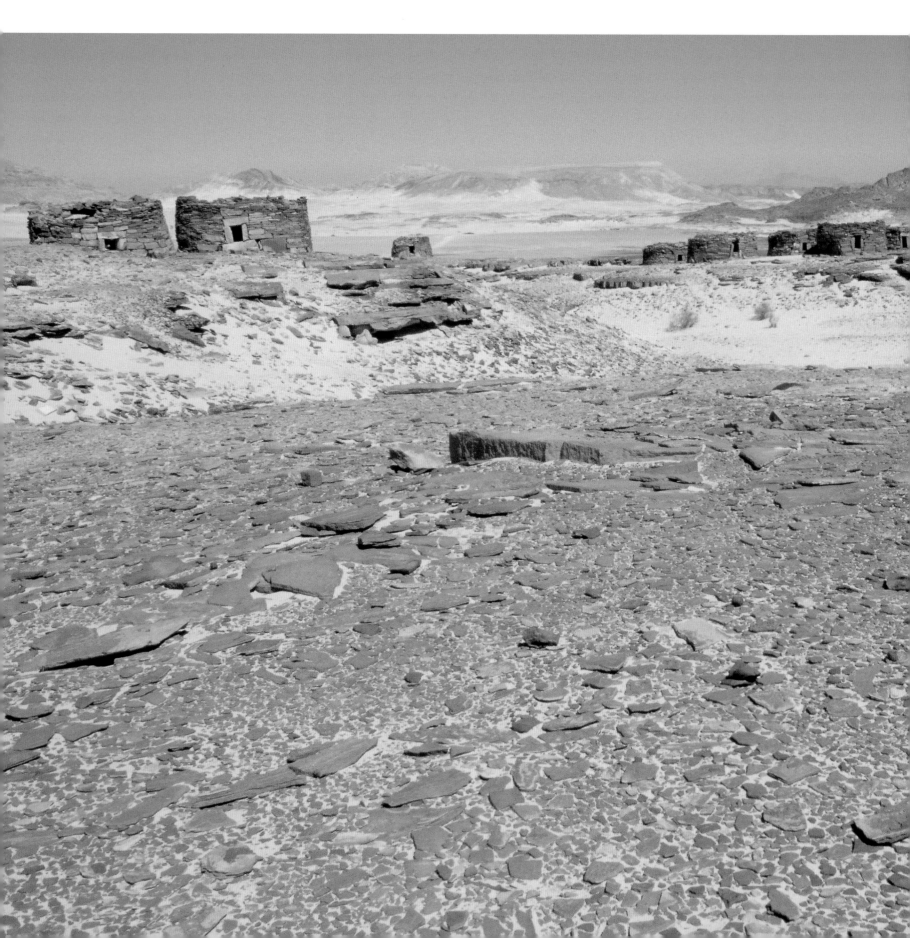

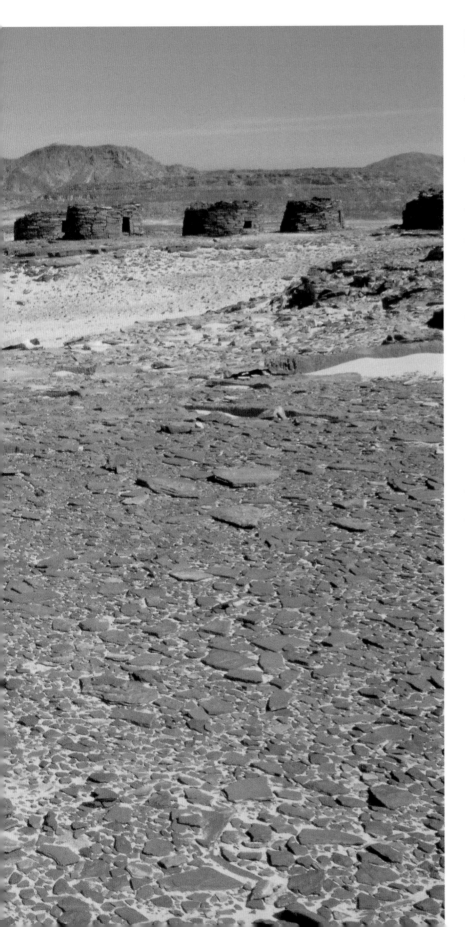

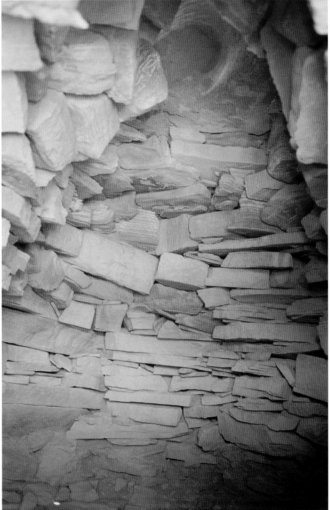

In the eastern Sinai, Avner Goren helped excavate an extraordinary site, two dozen round huts (*left*), like stone igloos, spread out over an area the size of two football fields. Each hut is about shoulder-high, constructed with overlapping slabs of sandstone (*above*). The bedouin name for these constructions is *nawamis*, which means "mosquitoes." The bedouin told Avner the huts were constructed by the Israelites during the Exodus when they needed a place to escape the mosquitoes. The *nawamis*, though, are far older, from the mid–fourth millennium B.C.E., a thousand years earlier than the pyramids.

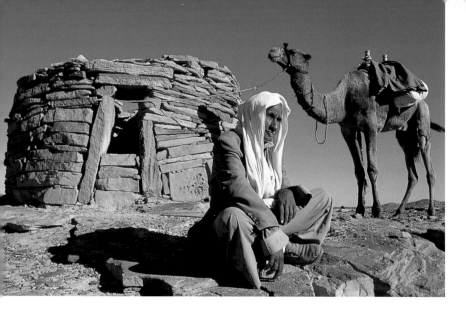

The *nawamis* are considered the oldest structures with intact roofs ever found, remnants of a six-thousand-year-old pastoral society. These structures were not residential but funereal. Since pastoral tribes never stayed in one place for very long, members temporarily buried their loved ones in the desert where they died. The tribe would return the following year to claim the bones and move them to a permanent burial spot. These bones were then interred in the *nawamis* in family groupings, along with ostrich-egg jewelry, jugs of oil, and other household items. These buildings suggest that not all humans crave living in urban areas, but some thrive in the desert, an idea echoed in the Bible when God forces the Israelites to spend two generations in the desert to overcome their sins as a nation.

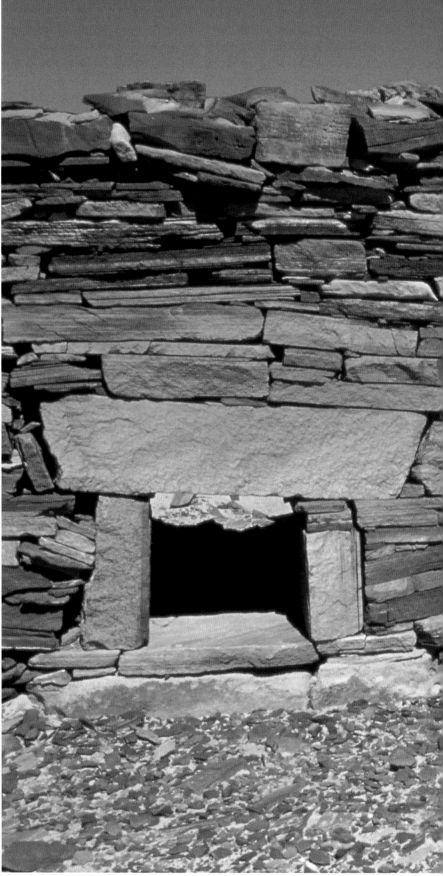

BRUCE FEILER

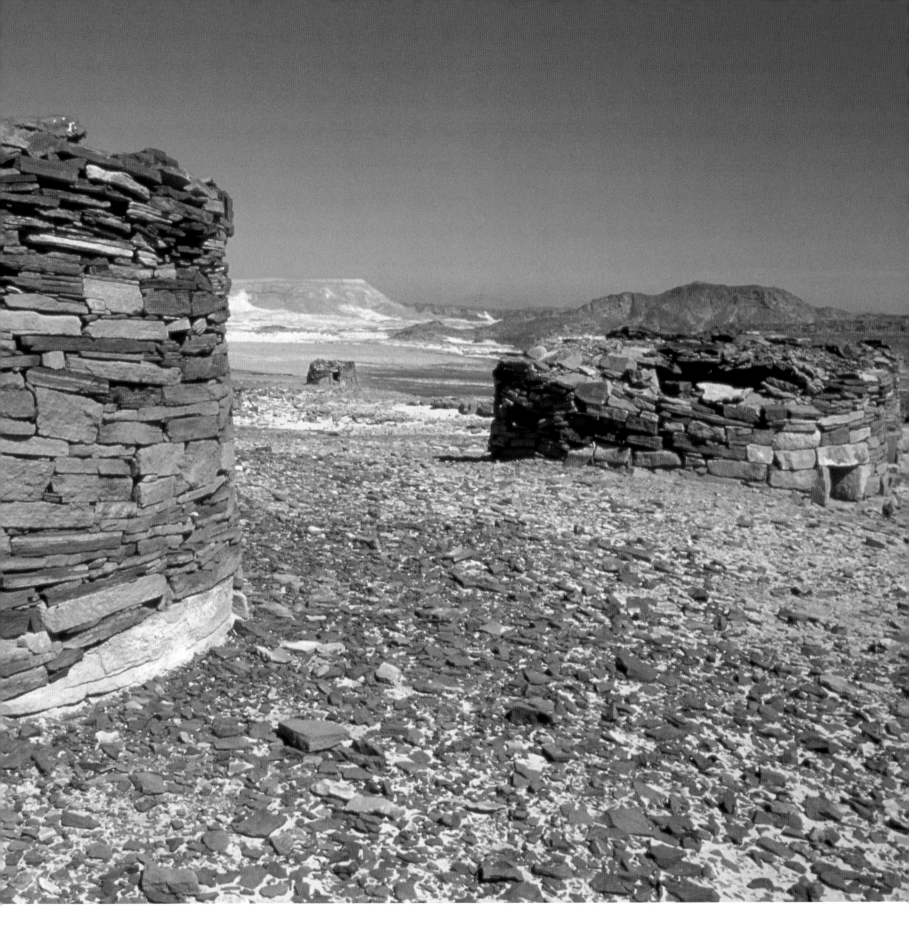

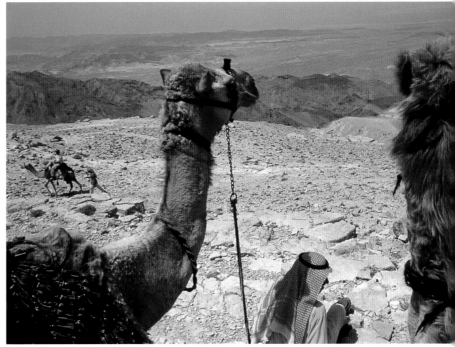

With the Ten Commandments delivered and the
Israelites on the brink of their destination, God asks
Moses to send a legion of spies to scout out the Promised
Land. They return after a little more than a month,
saying the land is too strong to conquer, prompting the
Israelites to complain that they should have stayed in
Egypt. God banishes the Israelites to roam the
wilderness for forty years. They settle in a place the
Bible calls Kadesh-barnea, which may be the northern
Sinai, the southern Negev, or southern Jordan, including
Wadi Rum (*left*) and the Syrian-African Rift (*above*).

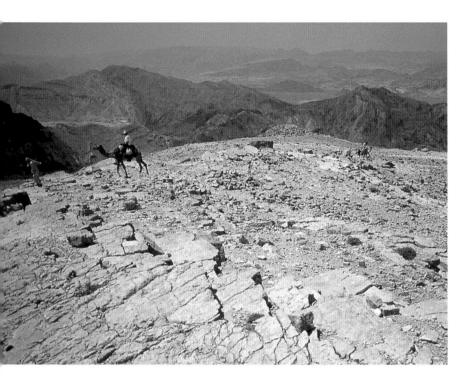

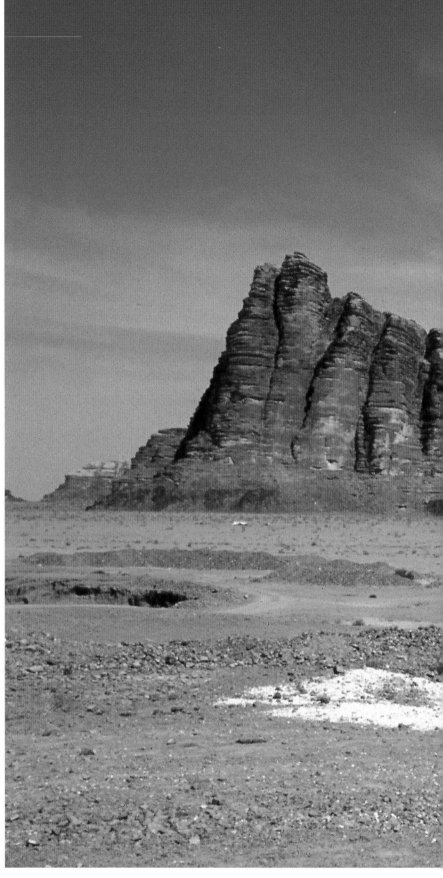

T. E. Lawrence "of Arabia" waged some of his famous battles in World War I in and around the deserts of southern Jordan (*above*). The title of his 330,000-word account of his time with the Arabs, *The Seven Pillars of Wisdom,* was drawn from this mountain (*right*) at the entrance of Wadi Rum. Published in a private edition of six copies in 1922, the work went on to become one of the best-selling books of the twentieth century and the most influential book published about the Middle East since the Koran. Lawrence wrote of Rum, "The crags were capped in nests of domes, less hotly red than the body of the hill; rather grey and shallow. They gave the finishing semblance of Byzantine architecture to this irresistible place: this processional way greater than imagination."

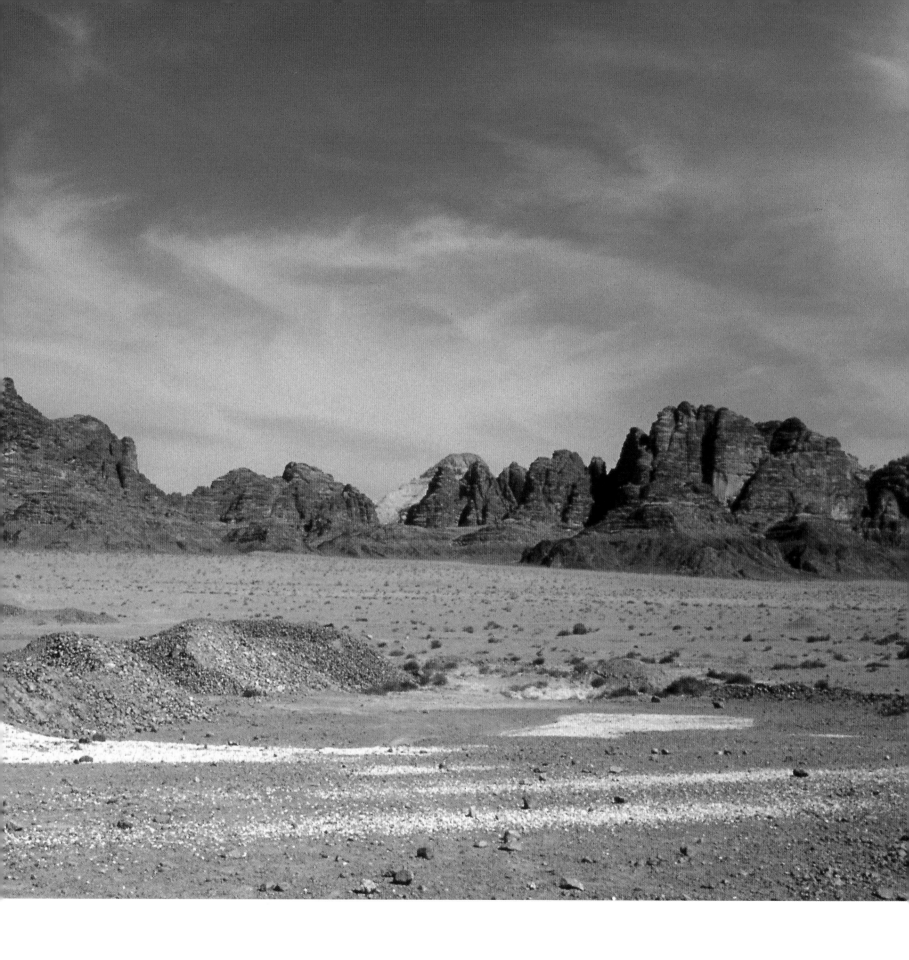

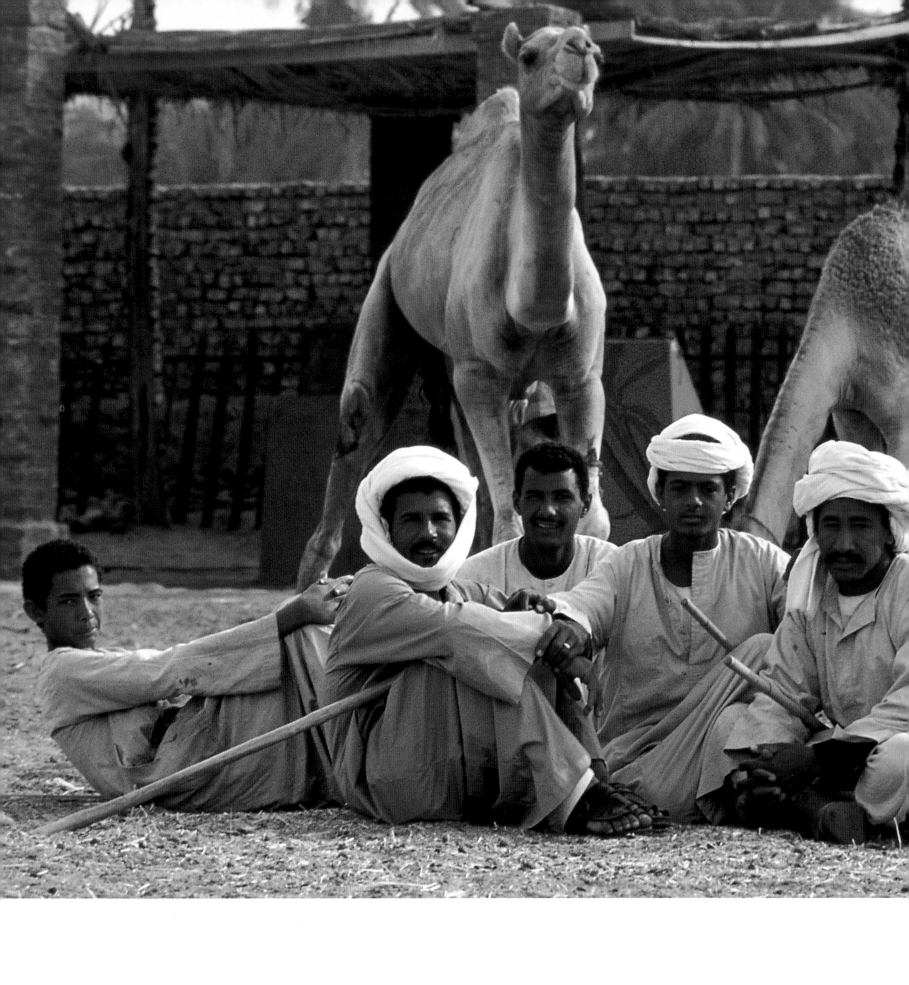

On their route toward Mount Nebo, the Israelites likely trekked up the eastern bank of the Jordan River on a road that stretches from the Gulf of Aqaba, north through Amman, up to Damascus. This road, which would have been popular with camel traders (*left and above*), is what the Book of Numbers calls the King's Highway. Abraham would likely have taken this road on his journey toward the Promised Land from Harran, and Jacob later took it on his way to and from his grandfather's homeland.

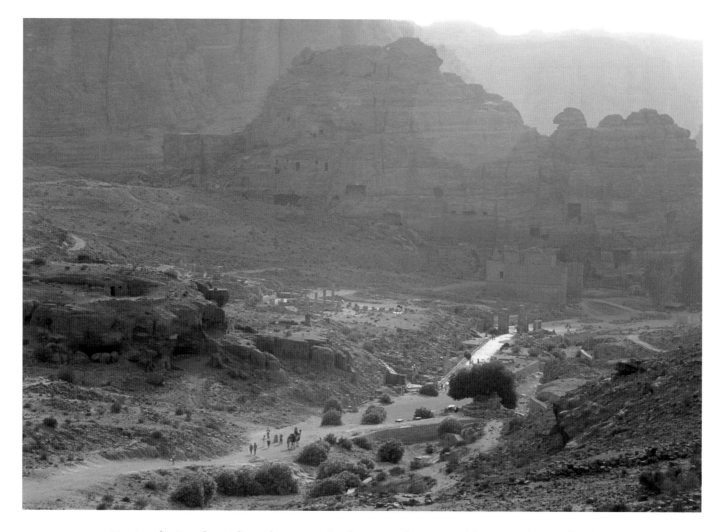

During the Israelites' fortieth year in the desert, as they are trekking up the east bank of the Jordan toward Mount Nebo, God announces, "Let Aaron be gathered to his kin," a biblical euphemism for *die*. Aaron dies "on the summit of the mountain," a location later associated with a hill above the ancient Nabatean city of Petra (*above and opposite*). The Nabateans, a desert people who lived in the Arabian peninsula, controlled the trade routes between Mecca and the Mediterranean. To reflect their power, this previously nomadic people built a capital city in Petra, in the hills of southern Jordan, in the fourth century B.C.E.

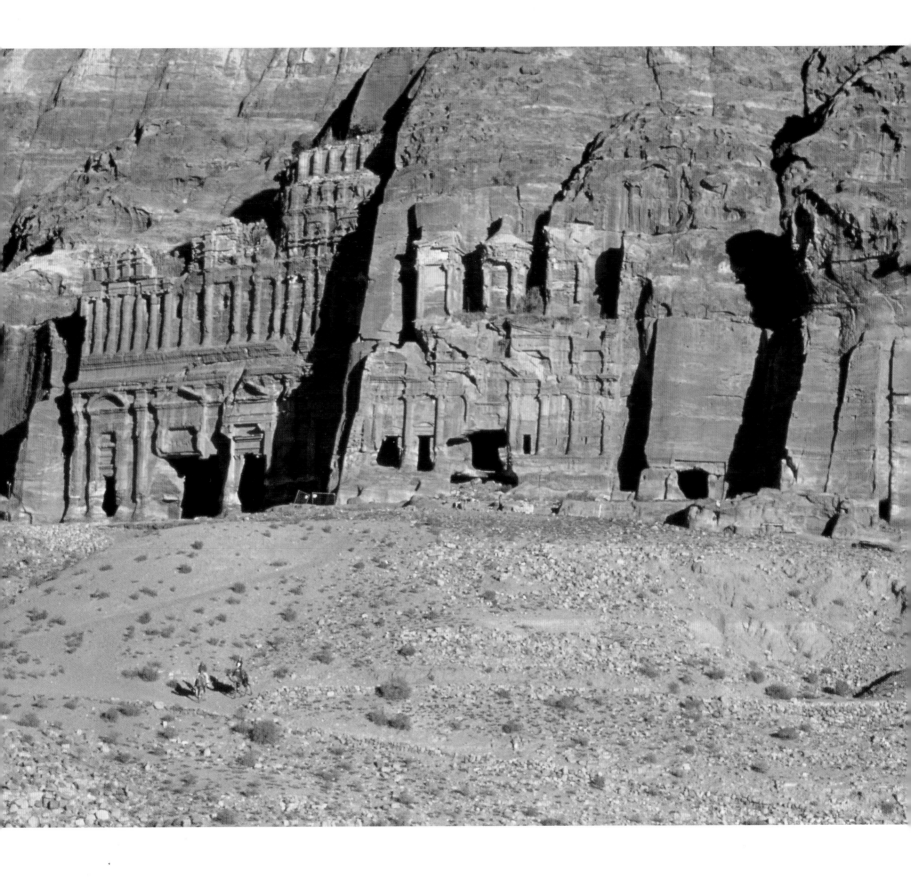

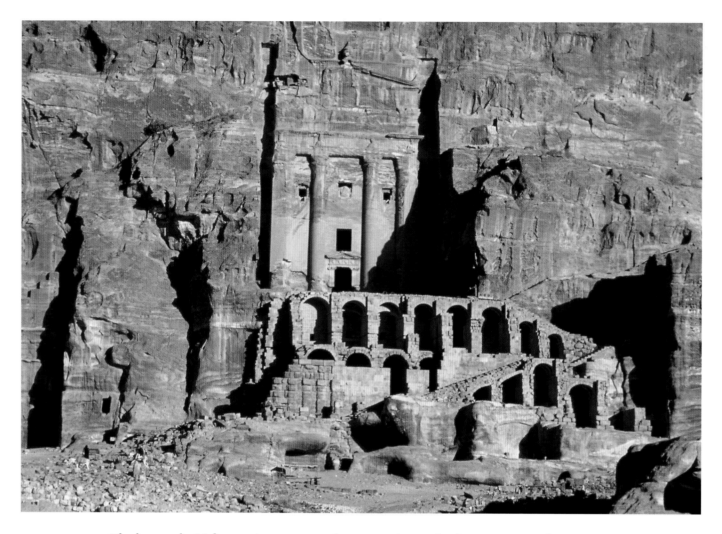

The key to the Nabateans' power was their control over frankincense, a product as popular as crude oil today. Made from resin extracted from a desert tree of the genus *Boswellia,* frankincense was valued for its sterilizing qualities and ability to cover up malodor in religious sacrifices. In Exodus, God instructs Moses to use frankincense in blessing the Tent of Meeting. The Nabateans used camel trains and hidden stashes of water to bring the product from Arabia to Damascus and Gaza. Petra represents their most permanent settlement. The buildings in Petra are not freestanding but are carved out of the sides of sheer sandstone cliffs. Most are not homes but burial sites; residents lived in tents.

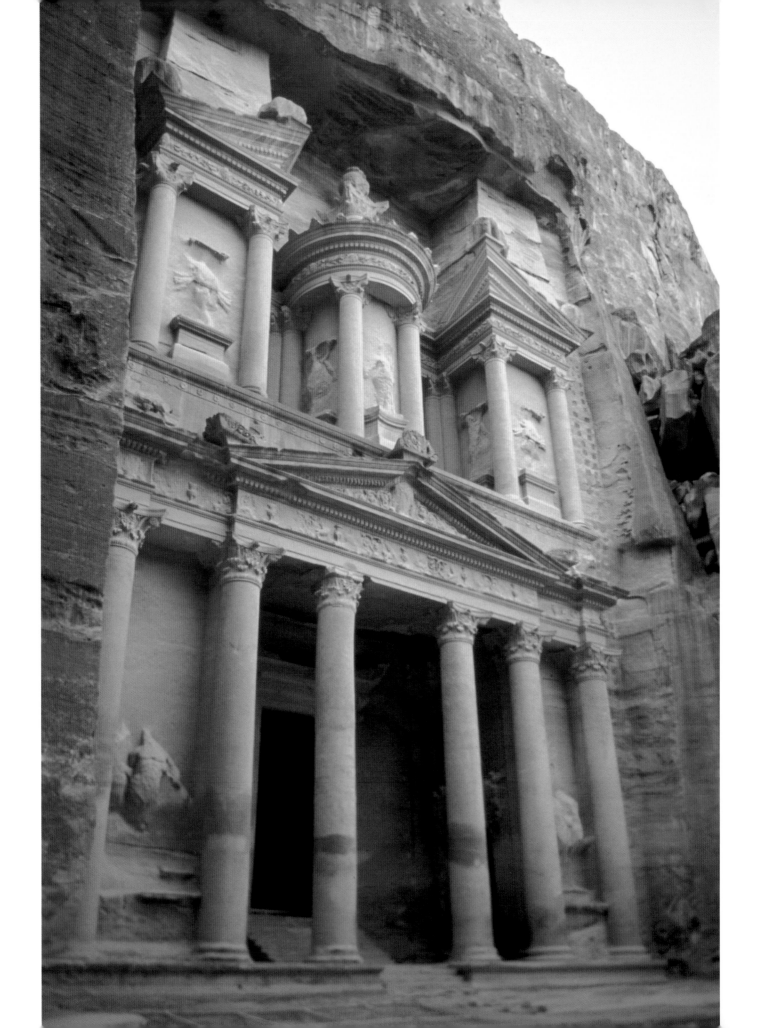

But the Lord said to Moses and Aaron,

"Because you did not trust me enough

to affirm my sanctity in the sight of

the Israelite people, therefore you shall not

lead this congregation into the land

that I have given them."

NUMBERS 20:12

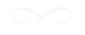

Petra's most famous site is the Treasury (*opposite*), which is
believed to have been completed around the first century
B.C.E. Its 120-foot-high veneer has columns, pediments,
and classical lions inspired by Athens. The Treasury,
which appears to visitors through a jagged opening in
the cliffs (*right*), also boasts a reproduction of Isis and a
ten-foot urn atop the central tower. According to tradition,
when the pharaoh pursued the Israelites after the
Exodus, he was so burdened by lugging his riches that
he deposited them in the urn. Later generations spent
countless rounds of ammunition trying to free the loot.

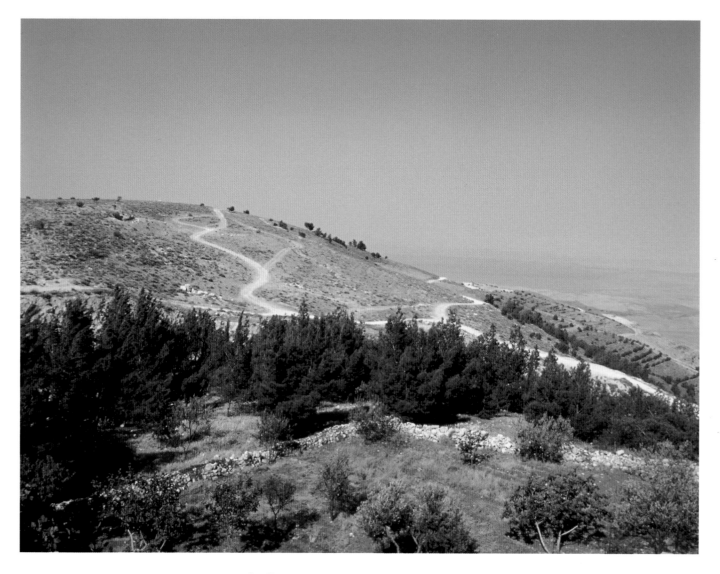

In Deuteronomy 32, God tells Moses to ascend the Jordan hills to Mount Nebo, "and view the land of Canaan which I am giving the Israelites as their holding. You shall die on the mountain that you are about to ascend." God reminds Moses that he is being denied entry because he broke faith with God by striking a rock earlier when God had asked him to speak to the rock. Like Mount Ararat, Mount Nebo has a natural claim to its identity: at 2,540 feet, it's the tallest in the area, though it's only a third as tall as Jebel Musa and an eighth as tall as Ararat. The mountain (*above*) consists of a number of peaks. Siyagah (*opposite*) is not the tallest, but it's flat, and holy buildings, including a Franciscan monastery, have existed on it since the first millennium B.C.E.

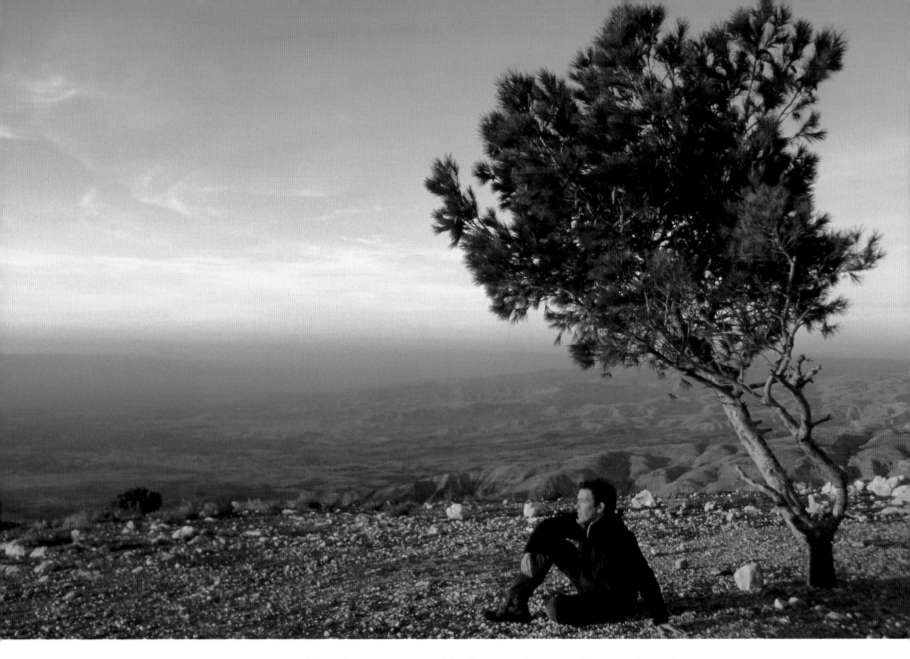

It seems impossibly sad that Moses could lead the Israelites out of Egypt, direct them for forty years in the desert, and beat back their rebellions, only to be stopped inches from the Promised Land. But on Mount Nebo (*above and, with a giant copper cross, opposite*), I began to see the story differently. Denied entry, Moses actually gets more: he gets a personal tour of the Promised Land from God. Still, it's impossible to see all the things that the Bible says Moses sees. The only way for Moses to see the complete dimensions of the land is by looking inward, toward his own internal geography. This is the lesson of Mount Nebo and the poetic twist at the end of the Five Books that helps make them such a hymn: the land is not the destination; the destination is the place where human beings live in consort with the divine. Ultimately, it doesn't matter that what the Bible describes is impossible to see. Because at the end, Moses wasn't even looking at the land. He was looking where we *should* look. He was looking at God.

BRUCE FEILER

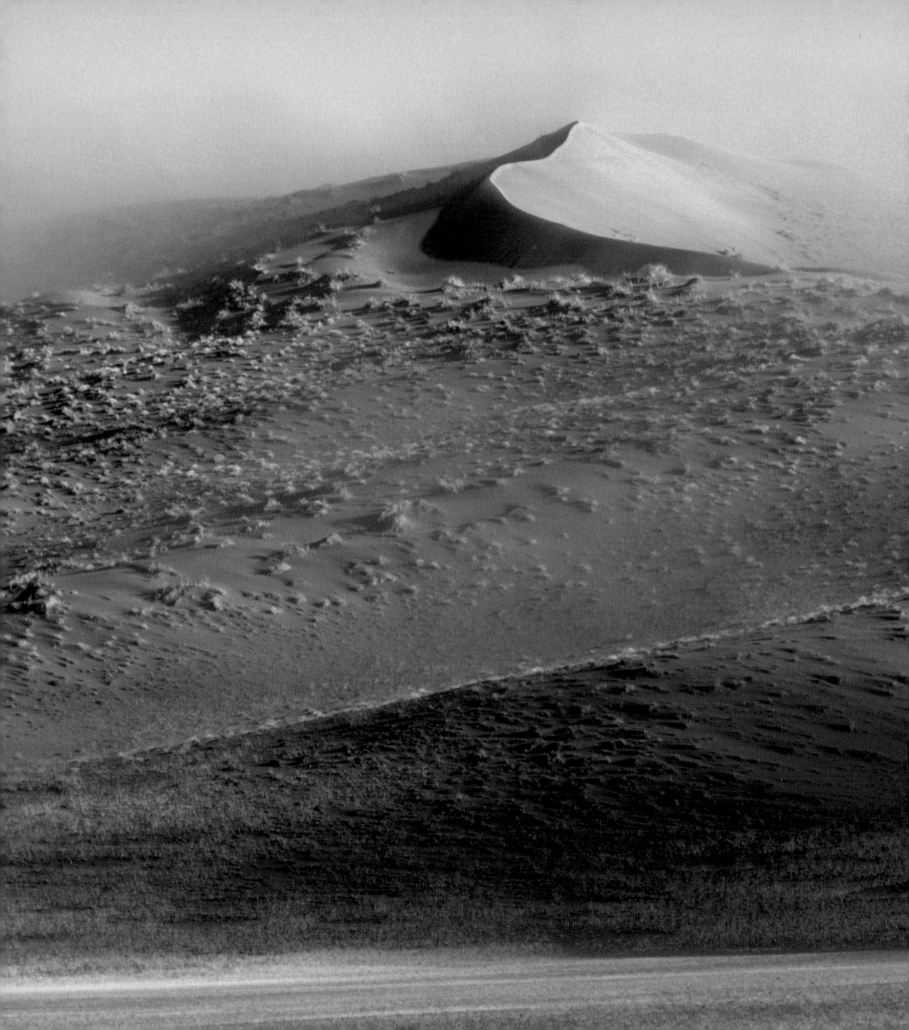

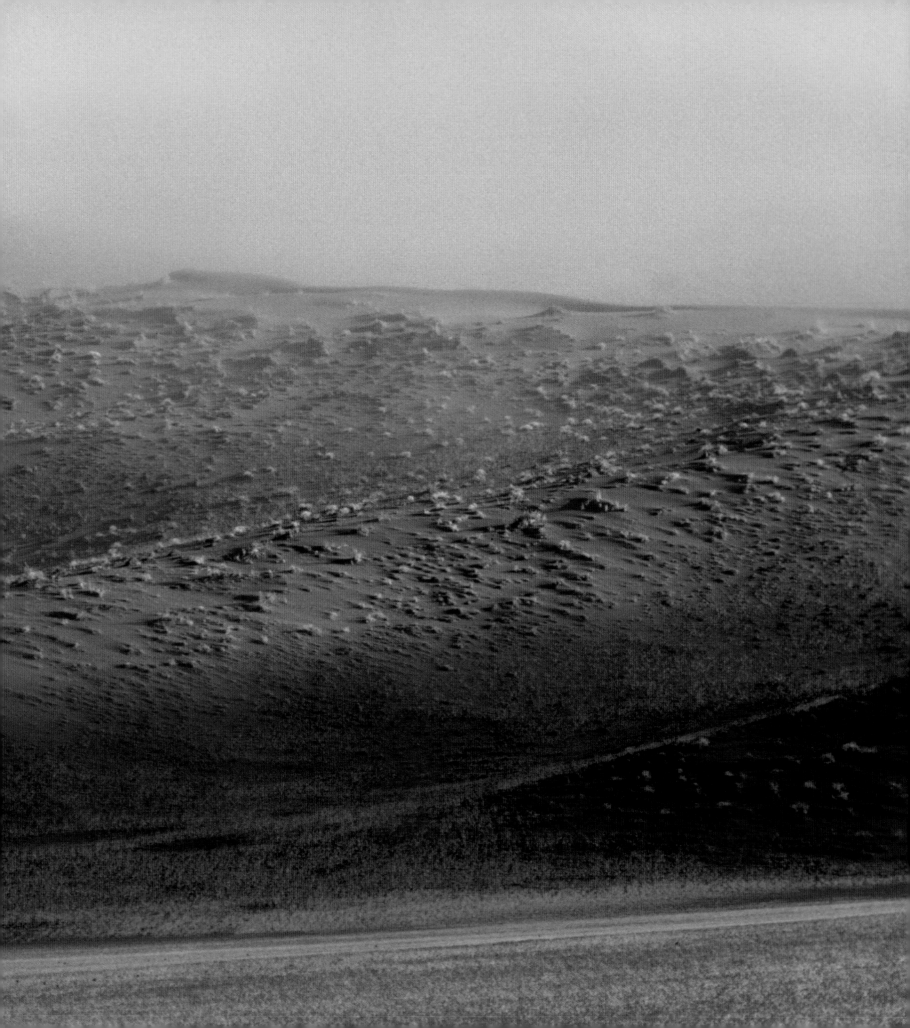

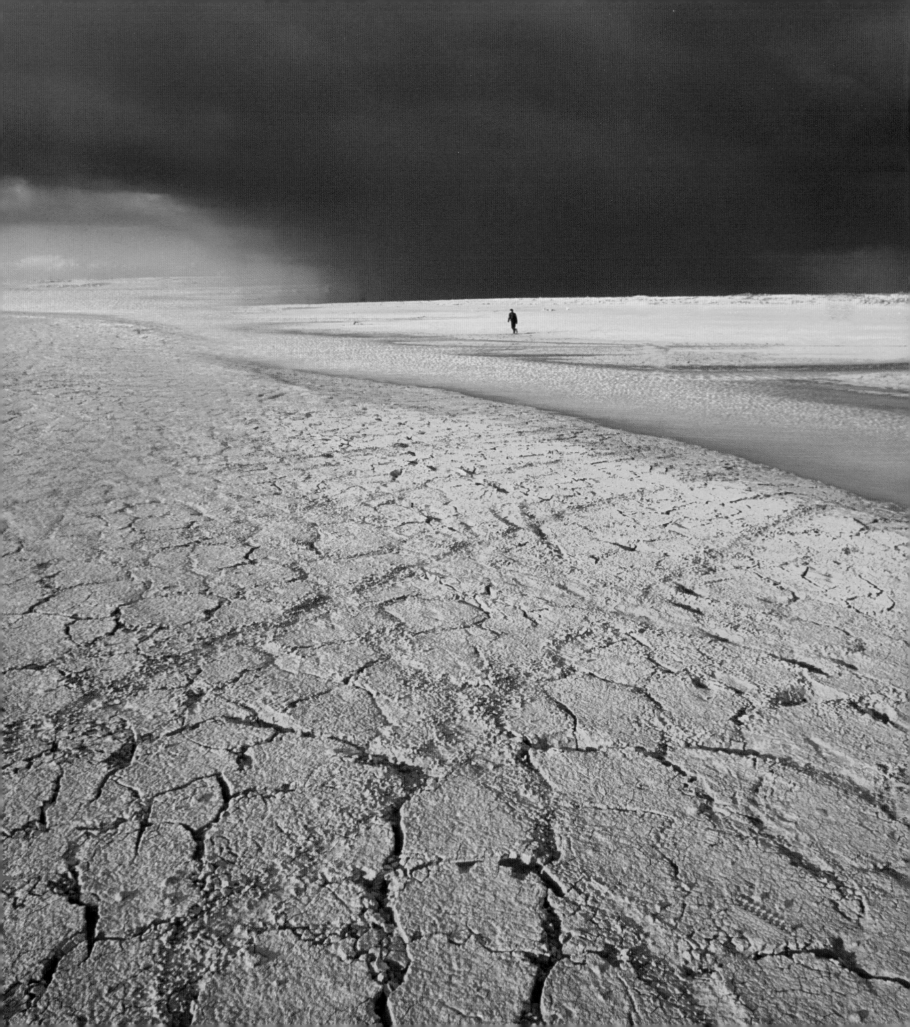

CONCLUSION

When I set out on my journey retracing the Bible, I convinced myself my trip was not about me, my spirit, or my God. It didn't take me long to realize that that idea was self-protective folly. It would be impossible to visit these places and read the story along the way and not come face-to-face with questions of faith and divinity. I became convinced that certain places in the world have emotional powers that live just underneath the surface, waiting for someone to come along, kick up the topsoil, and lie down on top of them. The most profound revelation of my travels was that the spirit of the Bible lives in *these* places—where its characters once walked and its stories were first told. That spirit also lives in me, and the two somehow met in the course of my journey. If that spirit is God, then I met God along my journey. If that spirit is humanity, then I met humanity. If that spirit is awe, then I met awe. Part of me suspects that it's all three, and that none can exist without the others. But what I know for sure is that I wasn't *discovering* something in these places. I was *recovering* something I already knew. The Bible is not an abstraction, that book gathering dust. It's a living, breathing entity, intimately connected to the land from which it sprang. And to all of us.

The biblical journey covers every inch of the
ancient Near East, from Mesopotamia to the desert.

∽ Acknowledgments ∾

This book is a tribute to collaboration. I am grateful to the wide range of people, on four continents, who worked closely together to create the television miniseries *Walking the Bible,* during which some of these images were taken. These dedicated professionals include Jim Coane, Rebecca Dobbs, Mick Duffield, Beth Gallagher, Alex Gregory, Peter Harvey, Drew Levin, Sally Thomas, and David Wallace.

David Black and I spent years imagining a book like this; it is a testament to his creativity. Henry Ferris helped design and execute every page, as well as inform it with passion and energy. Special thanks to Betty Lew and Laura Lindgren for the graceful design and to Beth Middleworth for the cover. As always, Michael Morrison and the team at William Morrow helped bring this to life. Thanks to Lisa Gallagher, Lynn Grady, Peter Hubbard, Karen Broderick, and Sharyn Rosenblum.

I am grateful for the love and support of my parents, Jane and Ed Feiler, Andrew Feiler, Cari Feiler and Rodd Bender, and especially Linda Rottenberg. One person, above all, has informed and enlivened my years-long search into the roots of the Bible. Avner Goren is a man of wisdom, humanity, and humor. I have happily walked in his shadow for what seems like a lifetime and most of the light that emanates from these images comes from his considerable soul. This book is dedicated to him.

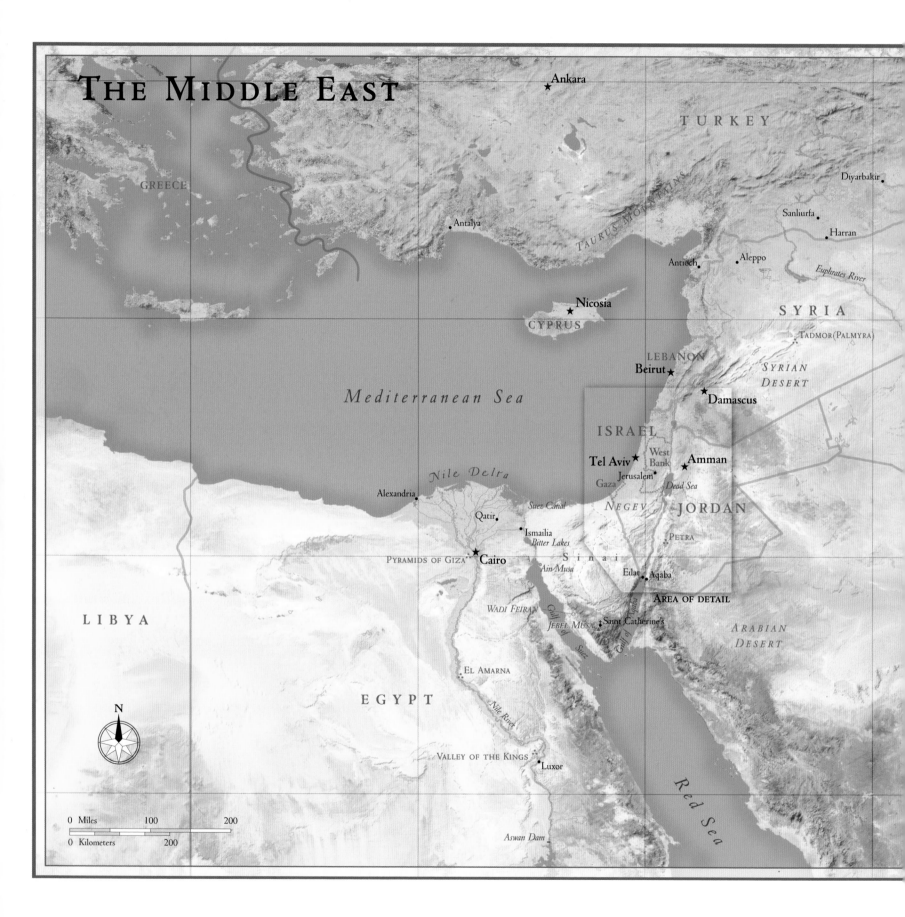

THE MIDDLE EAST

GREECE

TURKEY

Ankara ★

Antalya ·

Diyarbakir ·

Sanliurfa ·
Harran ·

TAURUS MOUNTAINS

Antioch · Aleppo ·

SYRIA

Euphrates River

Nicosia ★

CYPRUS

Tadmor (Palmyra) ·

SYRIAN
DESERT

Mediterranean Sea

LEBANON

Beirut ★

Damascus ★

ISRAEL

Tel Aviv ★ West
Bank

Amman ★

Nile Delta

Jerusalem
Gaza

Dead Sea

JORDAN

Alexandria ·

Suez Canal

Negev

Qatir ·

Ismailia ·
Bitter Lakes

Petra ·

AREA OF DETAIL

PYRAMIDS OF GIZA ★ Cairo

Sinai

Ain Musa

Eilat · Aqaba ·

LIBYA

Wadi Feiran

Jebel Musa · Saint Catherine's

ARABIAN
DESERT

EL AMARNA ·

Gulf of Suez

Gulf of Aqaba

EGYPT

Nile River

N

VALLEY OF THE KINGS · Luxor ·

Red Sea

0 Miles	100	200
0 Kilometers	200	

Aswan Dam